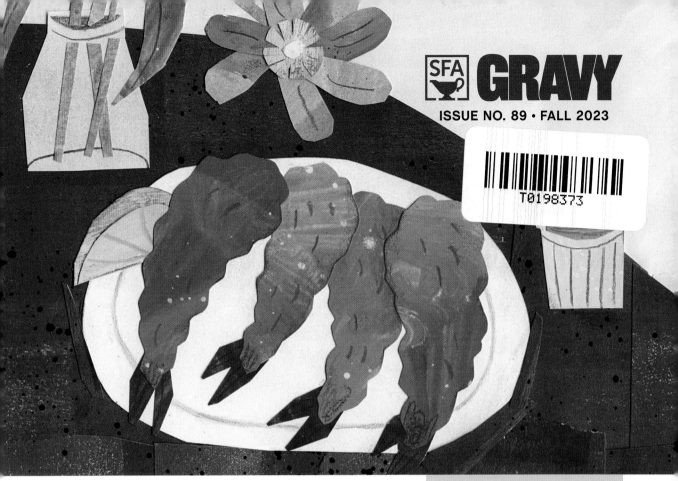

SFA GRAVY

ISSUE NO. 89 • FALL 2023

T0198373

Contents

Gravy is a publication of the Southern Foodways Alliance, whose mission is to document, study, and explore the diverse food cultures of the changing American South.

SARA CAMP MILAM
Editor in Chief
gravy@southernfoodways.org

ROSALIND BENTLEY
Deputy Editor

BITA HONARVAR Image Editor

RICHIE SWANN Designer

OLIVIA TERENZIO Assistant Editor

KATIE CARTER KING Copy Editor

**MELISSA HALL AND
MARY BETH LASSETER**
SFA Executive Staff
info@southernfoodways.org

FEATURES

ON THE COVER AND ABOVE: Illustrations by Jade Johnson

BEATEN BY BISCUITS

Rolling out a unified theory of biscuitry is not so easy.

BY SARA CAMP MILAM

GRAVY COLUMNIST HANNA RASKIN WANTED to find out what happened to Bojangles' biscuits when they slipped the confines of the South. We were curious, too—after all, the question "Where is the South?" guides our programming this year. So curious, in fact, that when her initial reporting trip to Ohio was thwarted by a construction delay, we sent her to Illinois. When we signed off on Hanna's column topic, we weren't planning a biscuit issue. But thanks to some luck and good timing, a biscuit motif emerged. In addition to Hanna's peripatetic fast-food biscuits, you'll also read about two biscuit entrepreneurs, one past and one present. A century ago, Annie Fisher of Columbia, Missouri, parlayed her labor-intensive beaten biscuits into a catering juggernaut, achieving a level of financial success that was practically unheard of for a single woman of her place and time. Mackenzie Martin, an audio reporter and producer who told Fisher's story for a recent episode of *Gravy* podcast, brings it to the pages of this issue. In twenty-first century Atlanta, former software engineer Erika Council's talent for baking tall, fluffy buttermilk biscuits evolved from a hobby to a pop-up business to a storefront. Deputy editor and fellow Atlantan

Rosalind Bentley interviews Council about her new cookbook, *Still We Rise*, which pays tribute to Council's ancestors and to unsung figures of Black culinary history amid recipes and techniques for dozens of biscuits and biscuit fixings.

You don't need me to tell you that Southerners have *feelings* about biscuits. But as this biscuit-laden issue came together, I sought to understand why. Over the course of a week, I polled my colleagues about their biscuit preferences, their biscuit memories, their biscuit philosophies. I poked around on the internet, where there is no shortage of hot biscuit takes. I compared recipes. And—I'm embarrassed to admit this—I made my own buttermilk biscuits from scratch for the first time. They were flat and tough, with no layers to speak of.

I went back to Hanna Raskin, who offered the best theory I've heard: "I feel like the fewer the ingredients, the more room there is for opinions (see: barbecue)," Hanna texted. She's right—and to me, that barbecue analogy is key. Here are two of the most beloved, discussed, and debated Southern foods. With barbecue, it's safe to say that there are two non-negotiables: meat and smoke. That's leaving aside sauce, its own fraught

SFA GRAVY

Each year, dollars from generous donors help SFA support the work of nearly 100 writers, illustrators, photographers, podcast producers, and storytellers.

Hungry for more *Gravy*? Please make a gift today.

Gravy storytellers showcase a South that is constantly evolving, using food as a means to dig into lesser-known corners of the region, to complicate stereotypes, to document new dynamics, and to give voice to the unsung folks who grow, cook, and serve our daily meals.

Gravy serves up food for thought. Help SFA make sure there's plenty to go around.

SCAN TO GIVE

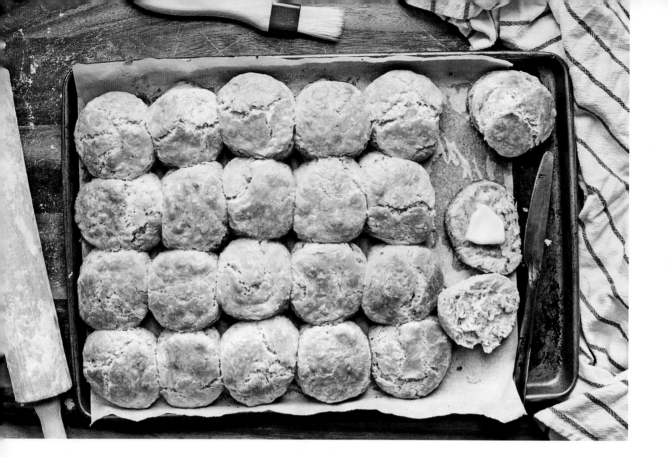

subject. I've seen biscuit recipes with as few as two ingredients and as many as seven, but flour, a solid fat, a liquid fat, and a leavening agent are basically standard. Salt—usually. Sugar? Sometimes.

In my week or so of biscuit immersion, I came across opinions, theories, and techniques that were contradictory to the point of comical.

Use the best butter you can afford. My father-in-law actually uses margarine. My mom made hers with Crisco.

Self-rising flour is unreliable. Self-rising flour is so much easier.

Fold the dough to make layers. Whatever you do, do not *overwork the dough.*

Bake at 425°. Bake at 450°. Bake at 475°.

While there were few points of consensus, there was also remarkably little snobbery among the folks I talked to. Most had respect for the fast-food category, detailing the merits of a favorite drive-through or gas-station biscuit. Many even copped to a soft spot for Pillsbury Grands, usually developed in childhood in the absence of a biscuit-making relative. Some regularly bake biscuits from scratch; others have never tried. But no one was mum on the subject. Say "biscuits," and Southerners start talking. (At least, they should. Pick up a copy of *Still We Rise* and turn to page 10 for a hilarious breakup story precipitated by biscuit indifference.)

Biscuits, like barbecue, are all over the South yet not limited to its historical boundaries. Both are easy to attempt and hard to perfect. No matter how you're making them, someone will tell you you're doing it wrong. I try to avoid referring to any culinary endeavor as magic, because it downplays the human skill at work. But an air of the supernatural does tend to permeate both. Their execution is cloaked in secrecy. Follow the recipe to the letter, and you might fall flat. Try again tomorrow, and the result could be totally different. Whether you're dining out or cooking at home, you're probably chasing an ideal, one that's been run through the sepia filter of nostalgia. You want the pulled pork from that roadside joint that closed down years ago, or the biscuits your grandmother baked when she was alive. You can't have them, but you can talk about them. Or write about them.

I'm planning to make biscuits again this weekend. Unlike last time, my expectations are low, which might set me up for success. But they probably won't live up to my own biscuit ideal, the pastrami biscuit sandwich from Neal's Deli in Carrboro, North Carolina. And if I turn out another batch of hockey pucks, I won't beat myself up. I've got a tube of Grands waiting in the fridge, just in case. 🍶

CENTER FOR
THE STUDY OF
SOUTHERN CULTURE

UNIVERSITY OF MISSISSIPPI

The Center for the Study of Southern Culture at the
University of Mississippi, located in Barnard Observatory,
is the home of the Southern Foodways Alliance.

COME STUDY WITH US

Be a part of innovative education and research on the
American South with our B.A. and M.A. degrees in Southern
Studies, and M.F.A. degree in Documentary Expression.

Visit **southernstudies.olemiss.edu**

FEATURED CONTRIBUTORS

CHRIS JAY is a writer, record collector, new father, and enthusiastic thrifter. He has an MA in folklore from Northwestern State University of Louisiana. Originally from Arkansas, he spent many years in Shreveport and now lives in Round Rock, Texas. His fall fantasy is to relive, one more time, an old seasonal ritual: a day spent shelling pecans and drinking whiskey-sodas with his late grandfather Joe Smith of Cullen, Louisiana.

JADE JOHNSON is a New Orleans–based illustrator specializing in editorial and book illustration. After receiving her BFA in Illustration from the Savannah College of Art and Design, she taught visual arts in nonprofit arts education programs until 2021. Using collage, her work is character-driven and explores connection through storytelling. She has yet to attend an outdoor movie in the fall, but vows to make it happen someday soon.

MARIA LOOR is an Ecuadorian-Colombian graphic designer and illustrator based in Los Angeles. She graduated with honors from Rhode Island School of Design and has lived in Guayaquil, Quito, New York, Buenos Aires, London, and Miami, where she has worked in advertising, branding, and printing while exhibiting her work and raising her two boys. Loor is senior designer at Jakks Pacific, where she has a blast designing packaging for toys. This season, she dreams of taking her wife to see the colors of New England in the fall.

MACKENZIE MARTIN is a James Beard Award–nominated senior podcast producer and reporter in Kansas City, Missouri, for KCUR Studios. She produces *A People's History of Kansas City* and a myriad of other podcasts. Her stories have aired nationally on *Morning Edition*, *All Things Considered*, *Marketplace*, *Here & Now*…and *Gravy* podcast! Her fall fantasy is to slice several different varieties of apples—her favorite fruit—very thin for a side-by-side taste test. A mug of hot cider wouldn't hurt, either.

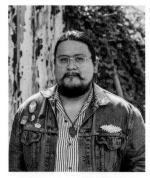

REYES RAMIREZ is a Houstonian, writer, educator, curator, and organizer of Mexican and Salvadoran descent. His short story collection, *The Book of Wanderers*, was a New York Public Library Young Lions Fiction Award finalist. His poetry collection, *El Rey of Gold Teeth*, is out this fall from Hub City Press. His latest curatorial project is *The Houston Artist Speaks Through Grids*. A beer aficionado, his sweater-weather fantasy is to have the budget, time, and patience to make stews and sourdough bread weekly and pair them with his favorite beers—think gumbo with a double IPA.

BITA HONARVAR is *Gravy's* image editor. Honarvar worked at *The Atlanta Journal-Constitution* for sixteen years, first as a staff photographer and later as the photo editor. She was also the senior photo editor at Vox.com. Her recurring fall fantasy is to enjoy crisp, consistent fall temps once September rolls around—an utter pipe dream, given she lives in soupy, subtropical Atlanta. She makes up for it by escaping to New England almost every fall to visit her college friends.

SFAMVP

KRISTEN FARMER HALL'S Birmingham

IN 2013, KRISTEN FARMER HALL WAS WORKING IN MEDICAL FUNDRAISING AND COMMUNITY relations for the University of Alabama at Birmingham when, she says, "pastry chose me." She began baking pastries with her two young daughters and leaving the treats on neighbors' doorsteps, earning the trio the nickname "the Baking Bandits." Hall started a Bandit Pâtisserie pop-up before selling at the Pepper Place Farmers' Market. Eventually, her boss asked her to choose: her job or her hobby. She submitted a resignation letter the next day. "I'd always done the right thing, always been on the straight and narrow," she says. "This was something totally different." A year later, she met chef Victor King, who became her business partner. Today, they own and operate The Essential, an all-day American café; La Fête, a French bistro and wine bar; and Bandit Pâtisserie, a small-batch, seasonal bakery. Here, Hall shares her favorite places to unwind in the Magic City.

La Fête

If I have to pick a favorite child, I'll pick La Fête in its new location [on Morris Avenue] and a seat at the pink marble bar. Last night I worked dinner service. The patio was full, and there was a little chill in the air. We played the original version of *Batman* in black and white. It was magic. My order is the country pâté and potato pavé—I eat them over and over, usually with a glass of riesling or white Burgundy.

Golden Age Wine

[My perfect] order would be sharing a bottle of riesling and a 50/50 [meat and cheese] board. I know the families who own Golden Age, so it's fun to go in there and see familiar faces and try new things. And the aesthetic—Amanda Loper is the architect, and she's wonderful. I love being in places that are thoughtful.

Chez Fonfon

My life is chaotic and a *lot*. If I'm going out into the world, I go to places that feel like home. We sit at the bar. It's a nice place to rest. My order is the seasonal tartine or escargot, or sometimes an omelet and a pot de crème with espresso.

June Coffee

A cappuccino outside on the patio. It's so fun for me to be in another space downtown that isn't mine, and see other people in their shops. Most people have no idea what goes into opening a brick and mortar. To see other people doing it at the level they do is very encouraging. And the coffee is delicious.

Illustrations by Bridgette Blanton / Tiny Pencil Studio

Most Visited Places is an ongoing digital and print series underwritten by The Mountain Valley Spring Water.

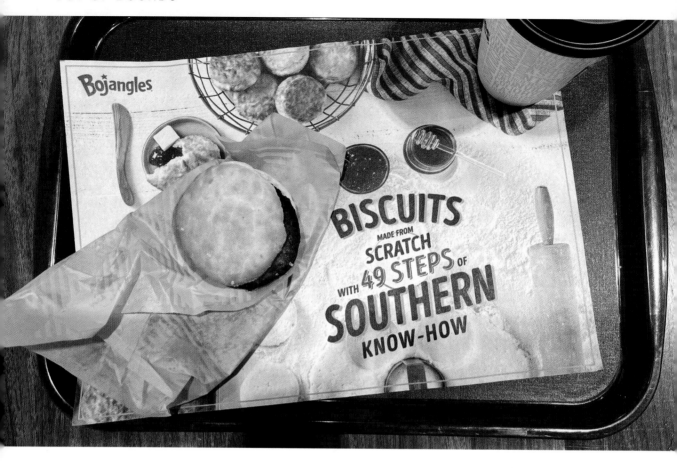

RISE AND SHINE?

As it expands into the Midwest, Bojangles
risks losing something in translation.

BY HANNA RASKIN

Photos by Hanna Raskin

KORRIE GORMAN HEARD THE NEWS FROM her friends. Then she shared the intel with her eight-year-old daughter.

Bojangles was coming to Columbus, Ohio.

"We love it so much," said Gorman, who lives about thirty minutes west of the new-construction nexus where the Charlotte chain situated its fourth Midwestern location. Previously, she could only get her Bojangles fix on road trips. "We always stop at Bojangles for a chicken biscuit on the way to Florida."

In much the way that a changing climate has dislocated weather events—with snow falling on Los Angeles and heat waves enveloping Portland, Maine—recent economic and demographic shifts have scrambled the fast-food restaurant map. Now eaters in a hurry can order a Torchy's Tacos' beef burrito in Raleigh or a Culver's root beer float in Rogers, Arkansas.

At the time of this writing, it wasn't yet possible to score a Bojangles' biscuit in the Buckeye state. Following a January groundbreaking, construction on the restaurant—the first of fifteen Bojangles planned in central Ohio—was delayed repeatedly by uncommonly wintry conditions. Blame the aforementioned climate change.

I paid a visit to the unoccupied building this summer anyhow, curious about what culinary philosophies or breakfast practices Bojangles might bring beyond the South as it presses ahead with expansion to Chicago, Baltimore, New York City, and Las Vegas, a city where twenty new locations are in the works.

Obviously, cultural diplomacy isn't Bojangles' calling. It's been a privately held company since a pair of New York investment firms acquired it for $593 million in 2019, which means its purpose is profit. Presumably, that's why the chain announced this year that all new locations henceforth will serve boneless tenders, rather than chicken by the piece, and sell blueberry milkshakes.

Still, I wondered: Could a chain identified so definitively with the South nudge the region's boundaries outward a bit? Might its menu help establish havens of Southerndom in unexpected places?

That wasn't what was on Gorman's mind when I met the interior decorator in a parking lot adjacent to the forthcoming Bojangles. As she surveyed the boxy beige structure, emblazoned with the slogan NEXT LEVEL SOUTHERN FLAVOR SINCE 1977, she thought back on those road trip sandwiches.

She was sure she'd never tasted anything like them in her hometown.

"Maybe Chick-fil-A is similar," she said tentatively, seeming reluctant to offer an answer that could be construed as not-nice. "But they don't have those biscuits."

EVEN THOUGH COLUMBUS, Ohio, is proud of its status as a doughnut town, it's not devoid of biscuitry. Local versions may not possess the otherworldly powers attributed to the pastry by smitten Southern eaters and upbeat Bojangles execs, but there isn't much involving flour that Midwesterners haven't mastered.

At least until Bojangles opens, the best-known biscuit in the Columbus area is the one on the menu at Bob Evans. The 437-location casual dining chain and freezer-aisle favorite is headquartered just north of the city. Developed to accompany gravy made from Evans' sausage, the Bob Evans biscuit is famously six-sided. "Bob did it that way because it created less waste," said Casey Stevens of Plain City, Ohio, who worked in the company's test kitchen for seven years before losing her job in a round of pandemic layoffs. She launched her Biscuit Boss food truck in 2021.

"It took me about six months to perfect the recipe, but we've found a niche," Stevens told me on a Sunday morning, when her truck was parked at a plant nursery. "Biscuits are very versatile."

At Biscuit Boss, if customers are wondering what to order, Stevens is likely to suggest the French toast bites, made from chopped-up biscuits tossed in sugar and glazed.

Almost a century earlier, another Ohioan had an idea about how to reconfigure biscuits. Henry D. Perky invented the slim shredded wheat biscuit, promoted in 1922 as "delicious" when mounded in a bowl with hot milk. "It is the only cereal food made in biscuit form," a print ad promised.

It's not a rap on Columbus' biscuits to say their producers always seem to be on the lookout for something else to do with them. When I stopped by a café called Basic Biscuits, Kindness, and Coffee, the woman who took my order told me proudly that the bakery's biscuits made an excellent quiche crust.

REGARDLESS OF WHY Midwesterners value their biscuits, it's getting harder to find the homemade kind there, as Bojangles' strategists may have noticed.

"I'm a spoiled sunnabitch," Mark Van Hook, a fifty-six-year-old auto mechanic told me when I asked how he liked the biscuits and gravy he was eating at a Bojangles in Normal, Illinois. "I get up on Sunday and make my own biscuits and gravy."

Even though Van Hook learned biscuit secrets from his mother as a kid in nearby Bloomington, he agreed to meet his friend Rich Jones for breakfast at Bojangles because they both wanted sausage gravy. Jones, an auto body technician, explained, "They've got the market cornered now, because the only one that does biscuits and gravy anymore is—"

Van Hook interrupted, "Hardee's."

Nodding, Jones continued, "McDonald's doesn't do it. Burger King's never done it. When I worked at Dairy Queen, we used to make biscuits from scratch every morning, but Dairy Queen dropped breakfast all together. It's just Hardee's, but they want [six dollars] for it."

Unlike Van Hook and Jones, I don't have to look far for a superlative fast-food biscuit. There is a Bojangles nine blocks north of my house in South Carolina that serves a biscuit with boundless loft and a buttermilk twang. But on a recent Saturday, I went another 898 miles to try the biscuits—and test my theory of cultural seepage—at the northernmost Bojangles in the country.

In 2019, Bojangles partnered with Love's Travel Stops to open locations in states where it previously didn't have a presence. The outpost in Normal, one of three now operating in Illinois, opened in December 2022.

Since the restaurant is relatively new, I'm compelled to forgive the biscuit I was served, which bore an uncanny resemblance to a hamburger bun. When I posted a picture of my breakfast on Instagram, meaning no mockery, Southerners rose up in disgust.

"That looks awful," Davidson, North Carolina restaurateur Katy Kindred weighed in.

I didn't bother telling Kindred that it tasted as dense as it looked.

FOR KORRIE GORMAN'S sake, I hope the Bojangles employees in Columbus have greater biscuit facility. Maybe, like the workers at the Bojangles near my house, they'll tease each other about the broad contours of that morning's biscuits or ask customers if they wouldn't mind waiting a few minutes for the next batch.

Then again, maybe they won't. As a Normal employee who goes by the name Jay Dog has concluded, it's an attitude toward biscuits that determines the Southern feel of Bojangles, more so than the recipe for them, or even the intensive training that Bojangles offers.

Jay Dog is a big fan of the Southeastern United States. He was skeptical when a boss at another job sent him on a work trip to Huntsville, Alabama, but he came home to Illinois with dreams of going back. "I've been all over the United States, and I know where I would live and I would not live," he told me. "Alabama is in my top four."

According to Jay Dog, there is nothing Southern about the Bojangles in Normal, Illinois.

"Sorry, no," he said, pinning the difference on the people. In the South, "there's more of a folksy feel," he continued, describing the conversations he'd expect to overhear in a Southern Bojangles as, "'We're all here, and then after our time here, you're going to get the [utility] trailer, and we're going to do this [and] that.'"

Jay Dog was generalizing, of course. But I think what he meant is that Southerners are apt to think of food as part of life, rather than an interruption of it. As someone who grew up in Michigan, that read rings true. My family's 5 P.M. dinner often consisted of a dish romantically referred to as "meat-and-string beans," served with a glass bottle of pop that had been opened a few days prior and preserved with a plastic stopper. For years, I was baffled by people saying they liked macaroni and cheese because our household's version was boiled Creamettes studded with cubes of unmelted Kraft cheddar.

The enthusiasm that Jay Dog described is familiar to Shafkat Anowar, a *Dallas Morning News* photographer. In June 2023, he covered the opening of one of the first Bojangles in Texas—and the North Carolina transplants who eagerly flocked to it.

"We live so that we can cherish food, that is like the core part of the culture," Anowar, who was born in Bangladesh, said of his countrymen. "So, when I saw the excitement [at Bojangles], that made sense."

By contrast, Bob Evans' preference for culinary efficiency remains prevalent in the Midwest.

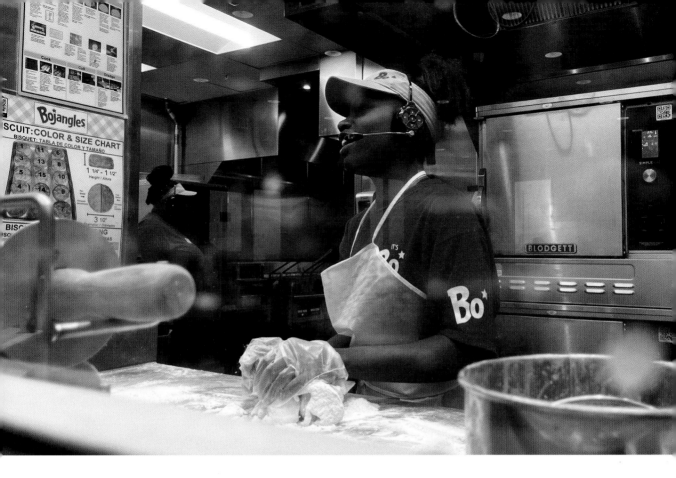

When I asked a desk clerk at the McLean County Museum of History if she could suggest somewhere distinctive for lunch, she instructed me to take a left on Washington, a right on Main, and another left on Front Street. The walk wouldn't take more than a minute or two, she promised, without providing the restaurant's name.

I looked at her blankly. "But what do they serve?" I asked.

"Oh," she said. "Salad."

BOJANGLES ISN'T LIKELY to budge that utilitarian approach to food, even if the names of North Carolina cities are printed on the restaurant's to-go cups, and a story about the company's founding is displayed prominently near the entryway to the dining area.

After all, restaurant chains aren't in the business of shifting cultural values, which is a risky proposition from a financial standpoint. Big food companies can amplify trends and perfect systems, but there's little money to be made in pioneering new ways of thinking. Americans liked getting pizza delivered before Domino's sped up the process. They enjoyed sugar in their coffee long before Starbucks rolled out Frappuccino drinks.

What fast food companies such as Bojangles do well is meet existing demands, such as central Illinois' desire for a freshly made biscuit, built to bear sausage gravy, rather than the cultural weight it carries in the South.

At Bojangles, Jones said, "I've never gotten a hard biscuit."

"That's what I hate about going to McDonald's sometimes," he continued. "I told them, I feel like I'm getting your leftover biscuit from yesterday. Like, I have to go back through the drive-through and say, 'Hey, can I get a soft biscuit?' …Ain't nothing more frustrating, especially if you're traveling on the highway."

In good capitalist fashion, Bojangles may have solved that problem. Under its deal with Love's, the chain is supposed to open forty locations at interstate exits across the country. So, like the Ohioans who associate Bojangles with long hauls, Southerners will soon be able to land a chicken biscuit after logging many miles on the open road—they just shouldn't expect to feel any closer to home. 🍸

Hanna Raskin is a Gravy *columnist. Her newsletter,* The Food Section, *is published on Substack.*

Pupusas

BY REYES RAMIREZ

the pupusa is a portrait
 of an honest earth:
 the coarse burns continents,
 the auroral dough a sea.
water joined masa through tumult
 & sphered, flattened then crowned,
 filled with meat & milk then smoothed,
 heat birthed & bitten.
no, the pupusa is an homage
 to the laborer's backhand
 where scars simmer & settle,
 strawberry skin browns.
sweated flesh crackles on steaming metal,
 grease singing smoke loud then sweet over & over,
 flipped & rested, an iris weepy then dry,
 ashen islands form & a back stiffens.
no, the pupusa is a documentation
 of every pecado,
 the taut pink palate
 a receipt for indulgence.
a sheet of young wood pulp dims,
 then an emergence of weighty shadows.
 a sycamore pith rises & splits
 & spits a globe of queso.
no, the pupusa is a bulging mirror
 to this sleepless face. examine
 the wrinkle bowls under each eye & find
 another tired eye under another tired eye.
the cream sol bulges then sombers,
 sunspots & scabs black;
 what can this light nourish
 but a body ripe with eonic exhaustion?
no, the pupusa is a portrait
 of this life, crusting & breaking
 with every lick & tooth, the desire & gift
 of jarabe yielding to the shape of a belly.
crack open the soft disc egg
 & study its ivory thick blood & tender marron,
 stretching like a timeline of grief,
 & lap the fresh veins.

Pozole

BY REYES RAMIREZ

examine handsome pork & note the vulnerabilities
 the ear's blush, the feet's foggy tendons,
 the ruby pierna's coat of grasa,
 a lightning of white cartilage.
 strip the gummy fat & know
 what must be made bare
place them all in la olla with streaks of coaled tears
 full of agua herviendo.
 what is any sabor but a flesh boiled
 until clouds of loam float
 to the water's screaming surface
 like souls to rapture?
skim the sputtering espuma. add ajos, onion, salt, bullion,
 whatever may grace throat & stomach
 with wax-thick broth.
 a recipe is a litany
 of what has nourished
 the history of your becoming.
 stir so nothing sinks & sticks
open latas of white hominy, handwash them
 like spilled teeth, like nascent pearls,
 like orbs of wisdom
 from the dead.
 continue boiling. continue waiting. continue living.
 remove what can no longer give: cebolla, garlic, doubt.
 add bay leaf. add oregano. add what cannot be said.
taste this labor. taste what's been tasted before you,
 what has provided clarity beyond hunger,
 what has been prepared to the singing
 of those who cannot hear your music,
 by those now in unwakeable sleep,
 through your mother's mother's hope,
 through the instinct to reach across a time
 & say You are here.
Is it possible to ever be alone?

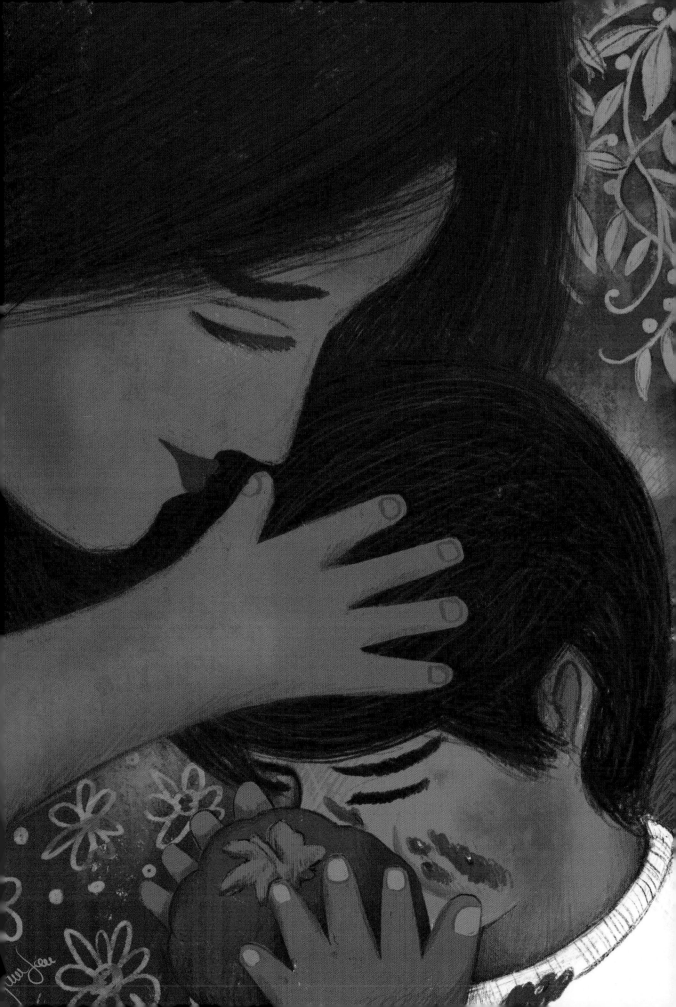

X. *Hijo, please*

BY REYES RAMIREZ

I don't like it when you say things
and you mean them. Cosas como
'no,' 'I don't care,' and 'ya.'
As if you want to go into another world.

Yo recuerdo when you were chiquitito:
you would eat tomatoes with picatitos
that wore away el piel,
chunky jugo trickling out.

You would never talk,
masticando tomatoes to the center,
never blinking, a stain of pulp roja
remained around tu cheeks y teeth.

Nunca did you make efforts to clean it off,
so I leaned in to wipe your face
and I would laugh and smile and say
mi niño, niño mío.

*Reyes Ramirez is a Houston–based writer,
editor, curator, and organizer of Mexican
and Salvadoran descent. These poems are
excerpted with permission from* El Rey of
Gold Teeth, *his new collection from Hub
City Press.*

OUR HOMES,
OUR HEALTH,
OUR FUTURE

AROUND
THE SOUTH IN
60 VIEWS

CELEBRATING
30
YEARS

Southern
CULTURES

FALL 2023 | **SNAPSHOT: CLIMATE**

Climate change in a changing region.

IN MORE THAN 60 PHOTOGRAPHS, the *Snapshot: Climate* issue presents
an on-the-ground look at climate impacts across the South. Subscribe now and
receive the *Snapshot: Climate* issue issue for free.

Read, subscribe, and more at **SouthernCultures.org**

WHERE **SCHOLARSHIP**
MEETS **STORYTELLING**

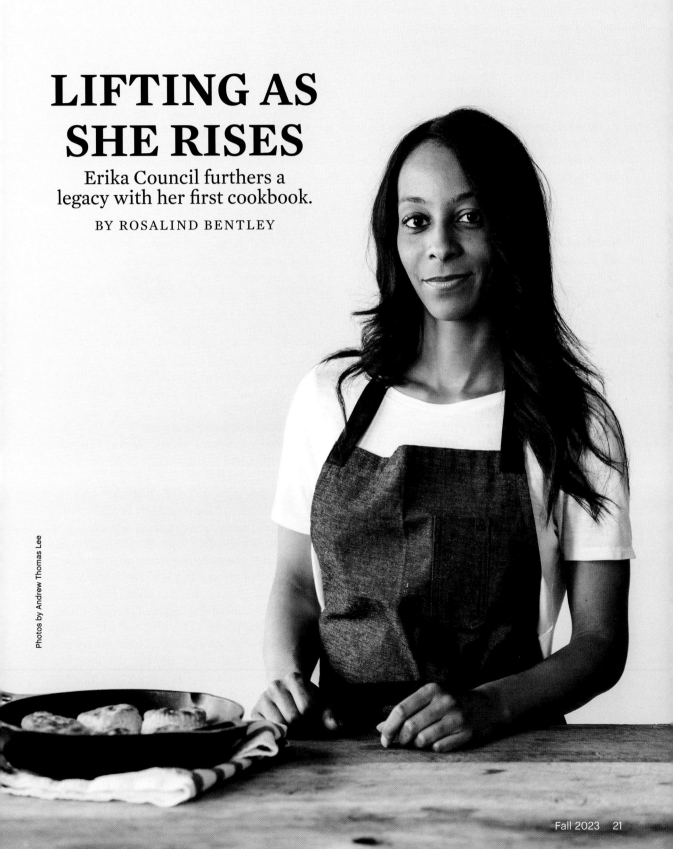

Baker, restaurateur, and cookbook
author Erika Council

LIFTING AS SHE RISES

Erika Council furthers a
legacy with her first cookbook.

BY ROSALIND BENTLEY

Photos by Andrew Thomas Lee

SOME PEOPLE HAVE THE TOUCH FOR MAKING THE MOST FLUFFY, CRUMBLY, RICH biscuits worthy of a lazy Sunday morning. Then there are others of us who can't make one worth a dime, despite fervent prayer. Erika Council, owner and chef of Bomb Biscuit Co. in Atlanta's Old Fourth Ward, obviously sits on a pew of the former. Watching her work the line in her kitchen alongside her team as they assemble SECs—sausage, egg, and cheese biscuits—hot honey fried chicken biscuits, and so many others, is confirmation that Council, a former STEM kid, is doing what she is called to do. The granddaughter of the legendary Chapel Hill restaurateur Mildred Council, known as Mama Dip, Erika Council has claimed her own space in the landscape with both her restaurant and her first book, *Still We Rise: A Love Letter to the Southern Biscuit*. Published this summer by Clarkson Potter, the book contains more than seventy recipes: chocolate chip, sweet potato benne seed biscuits, cola biscuits, and plenty of step-by-step instructions. Woven through its pages are stories of the Black women and men who cleared a path for Council, nurtured her, and who inspire her each time she adds flour to a mixing bowl and begins to make dough. For those of us who still aren't confident in our skills, Council advises maybe skip the duck-fat biscuits and start with her butter swim biscuits: "You mix everything in a pot or in a baking dish. Easy."

(This interview has been edited for length and clarity.)

Rosalind Bentley: *Tell me about your old day job, because I only ever knew you as biscuits. Then in a conversation, you slipped and said, "Well, girl, you know I'm a software engineer."*
Erika Council: My mom was a software developer for IBM in the eighties. One of the OG women. She worked in Research Triangle Park [North Carolina]. She had a huge laptop and like all the old mainframe and C++ and Python books stacked up in the corner. My mom could do this with hands tied behind her back; free-form [coding]. I was inspired. And I was in the INROADS program—they recruited African American kids to be more involved in technology. So, it was just

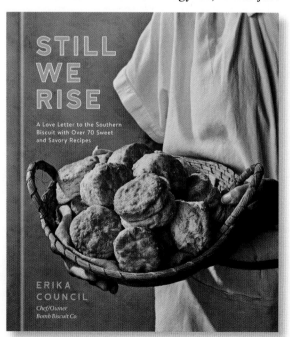

something that interested me early on, from the old-school Oregon Trail [computer game], mapping your way on that floppy disk.

I worked as a Salesforce developer from probably 2009 until I founded Bomb Biscuits in 2021. I was still doing freelance work at night...I would get up like 6 A.M., make biscuits, work all day, and then come home and from like, seven o'clock to one, two in the morning, work on help desk tickets.... Go to bed, get up, and do it all over again.

RB: *Talk about making a way.*
EC: I had to convince myself, before I stepped out on faith, that I could actually make this work. I'm still not convinced.

I'm not gonna lie: It's tough. But what does motivate me is when I have so many people coming in, like, "Oh, I saw your story, an African American restaurant in the Old Fourth Ward." I get those people coming into the restaurant and just telling me how proud of me they are. We're starting to get some kids in who want to learn how to make biscuits—African American kids. Teaching science through baking biscuits. I've done one or two things individually with some young girls whose parents were regulars and asked me, "Our daughter, she has all these cookbooks that are written by white authors, I would love for you to kind of explain it." So we made sourdough bread because I asked [her], "What do you want to know how to make?" And she says, "Well, do you know how to make sourdough bread? Because when I see that, that's not something African Americans make." And I made it, and I talked about my great-aunt Fanny,

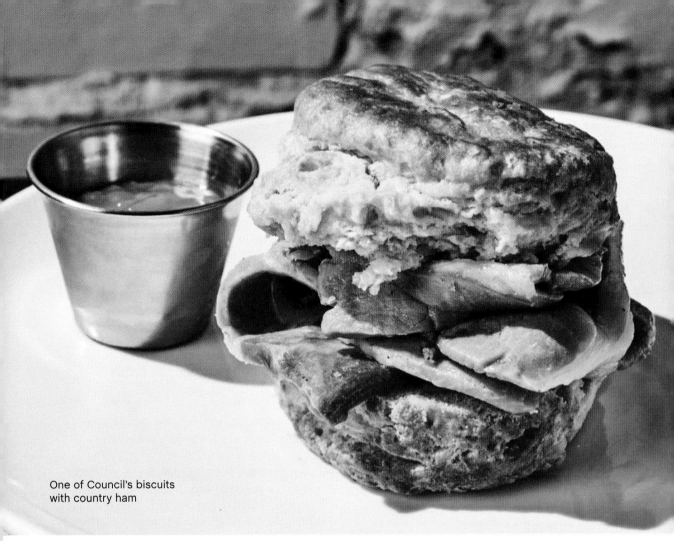

One of Council's biscuits
with country ham

who lived to be 103. She used to keep little jars [of starter] around her house and she would open them up and smell and determine which one she would use. It would be molasses in one, potatoes in the other. I mean, she used a lot of things to create sourdough. So, for me, it's just calling out these names of people that they don't see in cookbooks.

RB: *When you were making biscuits before you left Salesforce, was baking a release for you?*
EC: Yes, it was a way for me to sort of clear my mind. I make a lot of different breads, but I just become known for the biscuits. It's just therapeutic for me.

RB: *You talk about your paternal grandmother, Mama Dip. Let's talk about your other granny.*
EC: My granny Geraldine was the one who taught me how to make biscuits. I did not learn how to make biscuits from Mildred Council. My mom's

mom took time to show me how to roll and cut them out. She didn't actually say, "You need one cup of this and one cup of that." It was more, "You get some flour and put it in a bowl with some of this and that, use your hands, and roll them out. You'll be fine." But that's not teaching! [*Laughs*] When I look back at it, learning the art, watching, and mimicking was more so than, "This is step one. This is this is step two. This is step three."

RB: *You have a plethora of biscuit recipes throughout the book: rosemary-orange cream, sweet potato, corn, yogurt, duck fat. Do you have a preference for one or for a particular technique?*
EC: I love the [pull-apart] biscuits, where you bake them with the edges on. As a kid, I thought that was so amazing. We would get the edges and pull them off and dip them into gravy. That's kind of my favorite way to eat them, and you don't waste any scraps. ⚱

Rosalind Bentley is Gravy's *deputy editor. Erika Council serves on SFA's advisory board.*

Angel Biscuits

BY ERIKA COUNCIL

Angel biscuits use yeast in addition to baking powder to give them a little extra lift and fluff. They pop up tall, almost like those biscuits you buy in the can. We're going to leave behind those canned biscuits, though, because I was taught the only thing that should come out of a can is paint.

This recipe calls for letting the dough rest for about 30 minutes before folding and cutting out the biscuits. The rest gives the liquid more time to hydrate the flour and the yeast time to ferment, filling the dough with gas that will give these biscuits an airy texture. Angel biscuits make great dinner roll substitutes. I serve them more often during the holidays and at big family gatherings with just a slather of butter across the top.

YIELD: 15 to 18 biscuits

- 2 **cups full-fat buttermilk, warmed to 110°F**
- 4½ **teaspoons active dry yeast**
- 2 **tablespoons sugar**
- 5 **cups / 600 grams all-purpose flour, plus extra for folding and cutting**
- 2 **teaspoons baking powder**
- 1½ **teaspoons kosher salt**
- 1 **teaspoon baking soda**
- ½ **cup (96 grams) vegetable shortening, cold, broken into pea-sized pieces**
- 1 **stick (8 tablespoons) unsalted butter, cold**

1. Adjust the oven rack to the middle position and preheat the oven to 450°F.

2. Place the buttermilk, yeast, and sugar into a small bowl and stir gently to combine. Set aside until bubbles form on the surface of the mixture, 3 to 4 minutes.

3. Place the flour, baking powder, salt, and baking soda in a large bowl and whisk to combine. Scatter the pieces of shortening over the flour mixture.

4. Using the slicing side of a box grater, slice the butter into the flour mixture. Toss the sheets of butter in the flour and then lightly work the butter pieces between your fingers or use a pastry cutter to break them up and coat them with flour. Stop when the dough resembles coarse sand and there are still some small visible pieces of butter.

5. Make a well in the center of the mixture. Add the buttermilk mixture and stir gently with a spatula until the dough forms into a ball and no dry bits of flour are visible. The dough will be shaggy and sticky.

6. Cover with plastic wrap and set aside to rest in a warm, dry place for 30 minutes.

7. Turn the dough onto a lightly floured surface and lightly dust with flour. This dough is easier to shape using a rolling pin. With floured hands, pat the dough into a ½-inch-thick 11 x 6-inch rectangle. Fold the ends of the rectangle toward the center, one end on top of the other, to create a trifold. Dust the top lightly with flour, press out to the same size rectangle again, and repeat the folding. Repeat this process a third time. After the third folding, pat the dough into a ½ inch thickness and cut out the biscuits using a floured 2-inch biscuit cutter. Be careful to press straight down and do not twist the cutter.

8. Place the biscuit rounds 1 inch apart on a parchment-lined baking sheet. Gather the scraps. reshape them, and pat the dough out to a ½ inch thickness. Cut out as above. Discard any remaining scraps.

9. Bake 15 to 20 minutes, rotating the pan once halfway through, until the tops are golden brown.

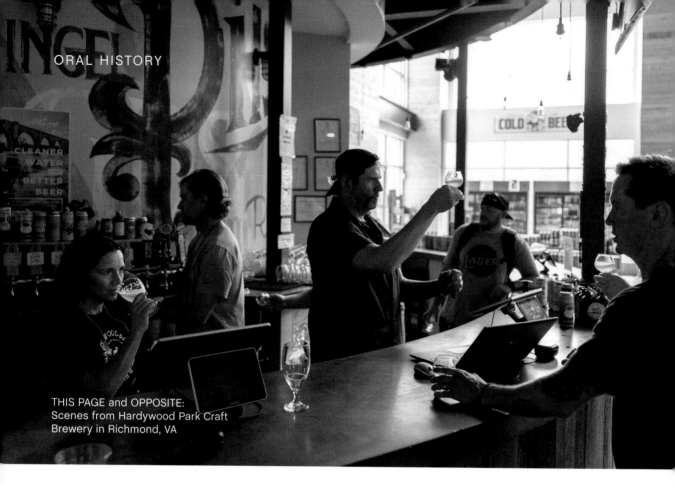

THIS PAGE and OPPOSITE:
Scenes from Hardywood Park Craft
Brewery in Richmond, VA

WHAT'S BREWING IN RICHMOND?

SFA documents the stories behind the suds.

ORAL HISTORIES BY SARAH I. RODRIGUEZ
PHOTOS BY PARKER MICHELS-BOYCE

CRAFT BEER HAS EXPLODED IN POPULARITY IN RICHMOND, VIRGINIA, IN RECENT YEARS. But the Virginia capital's relationship with beer goes back much farther: The first canned beer in the United States, a test run by Kreuger Brewing Company of New Jersey, went on sale in Richmond in January 1935. A few generations later, the Richmond beer scene exploded when the state moved to allow retail sales and on-site consumption at breweries in 2012. A wave of newcomers joined the city's few existing breweries in opening taprooms and adjoining restaurants. ¶ Through the growth and competition of the last decade, and in spite of the difficult Covid years, Richmond brewers overwhelmingly describe a close-knit, collegial local industry that supports and roots for the success of its peers. Through thirteen oral history interviews, SFA's Tapping into Richmond Beer project captures a snapshot of the city's brewing community. Read on to learn more about four of those brewers.

KATE LEE

Kate Lee is the president of Hardywood Park Craft Brewery, Richmond's second-oldest operating brewery. While in college, Kate developed an interest in the brewing process during a food science class on fermentation. She went on to have a twelve-year career at Anheuser-Busch, first in the quality department and then as assistant brewmaster at the Williamsburg, Virginia, brewery. After meeting Hardywood Park Craft Brewery co-founders Eric McKay and Patrick Murtaugh, she joined the Hardywood team as the quality assurance director in 2014. Lee's passion for her work is obvious; she is the kind of scientist who likens working with new strains of yeast to "meeting new friends." Not only did she develop Hardywood's quality program, but through the Virginia Craft Brewers Guild, she educates other brewers in the state about the importance of quality assurance and safety. In 2022, Lee became the president of Hardywood. Though she's less involved in day-to-day brewing in this role, she proudly name-checks the Virginia farms from which Hardywood sources ingredients like raspberries, ginger, honey, and malt—and she still gets excited when she sees customers line up for Hardywood's annual release of Gingerbread Stout.

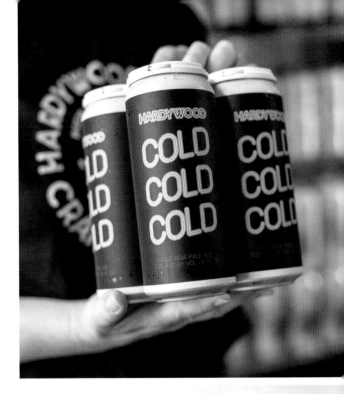

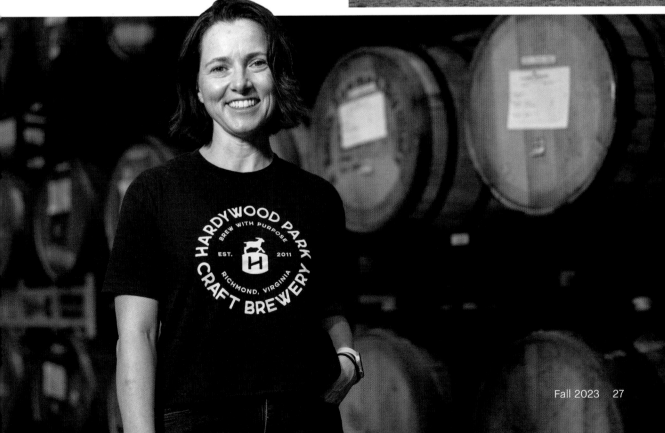

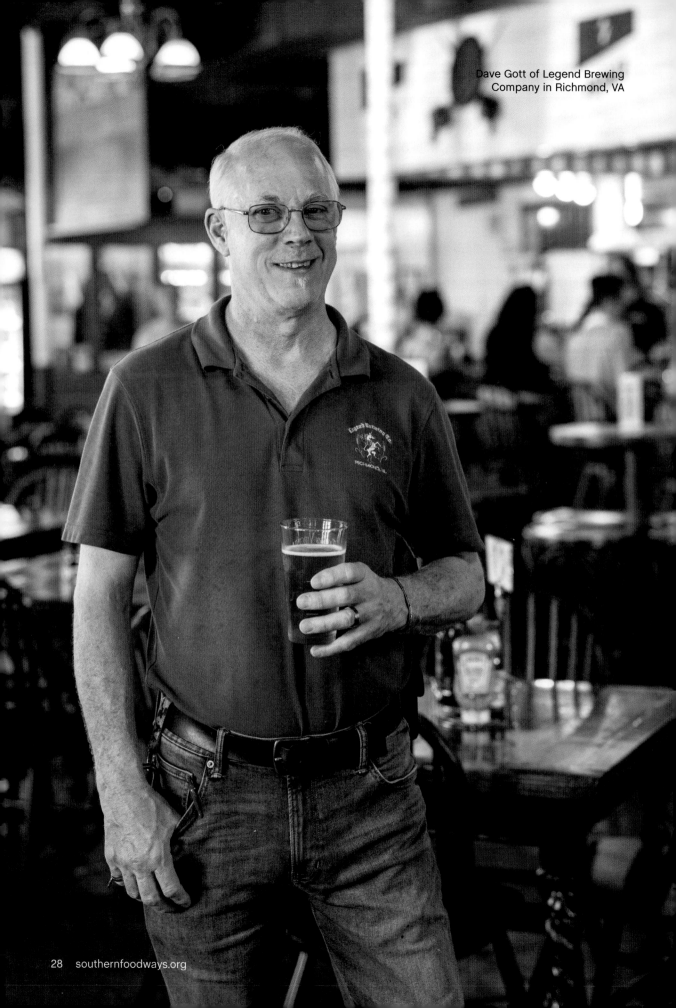

Dave Gott of Legend Brewing
Company in Richmond, VA

DAVID GOTT

David "Dave" Gott is the operations manager for Legend Brewing Company in Richmond's Manchester neighborhood. A native Richmonder, Gott first learned about beer from working at the Fan Market in high school and college. He worked in beer distribution before making the move to brewing. Gott joined Legend Brewing Company in 1996, when the brewery existed only as a small basement tasting room. At that time, Manchester was an industrial neighborhood, and many of the bar's regulars worked at a nearby tinfoil factory. Now, a new apartment complex with more than a hundred units is going up across the street. Gott hopes to see Legend serve as a hub for the growing Manchester community, just as it has for Richmond's brewing industry. Many of the city's brewers learned their craft at Legend, and Gott remembers them all. "In twenty-eight years, you make a lot of good friends in a business like this," he says.

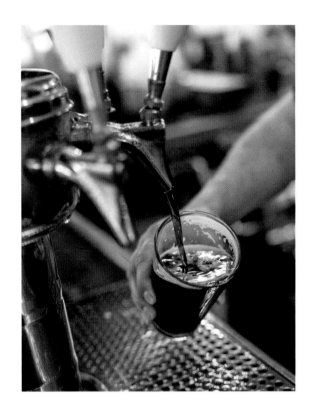

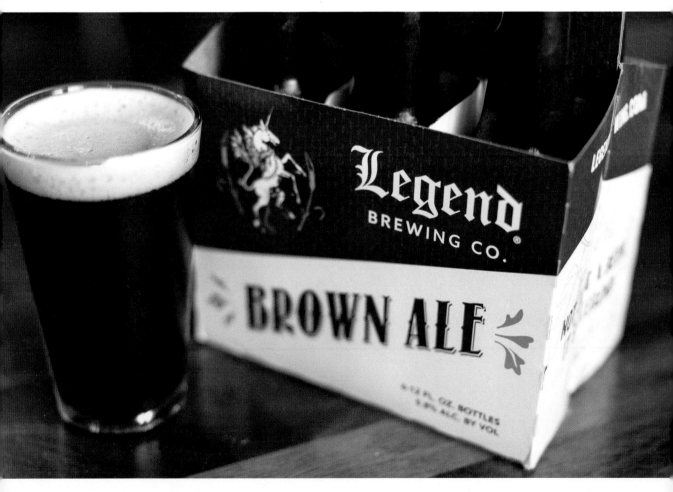

Scenes from The Answer Brewpub in Richmond, VA, including its game room with vintage pinball machines.

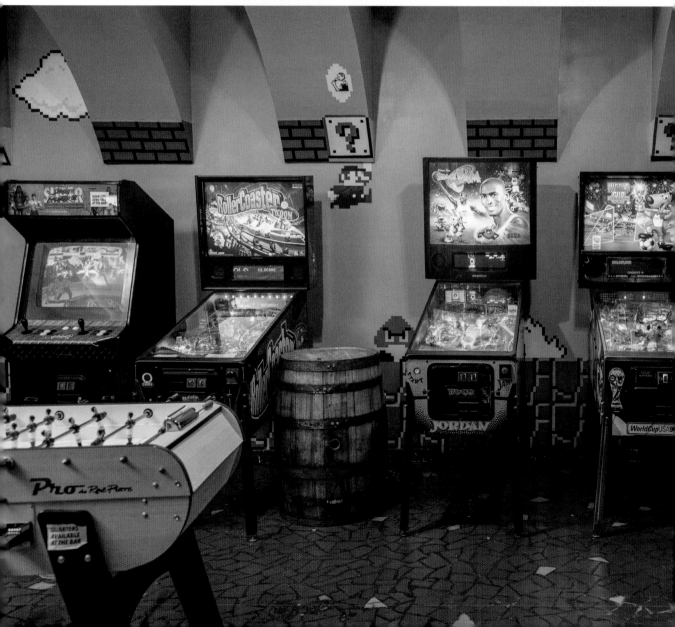

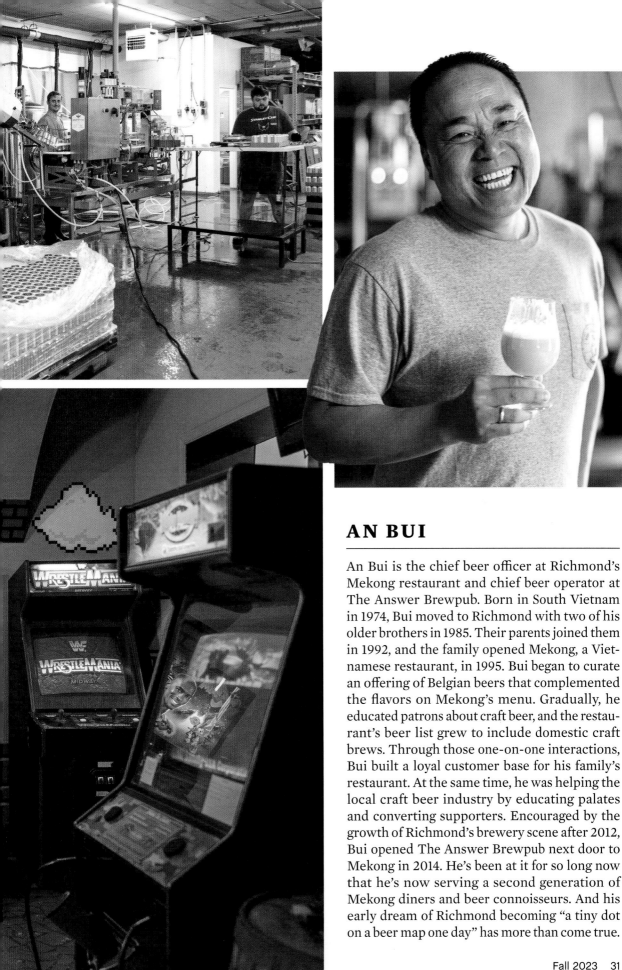

AN BUI

An Bui is the chief beer officer at Richmond's Mekong restaurant and chief beer operator at The Answer Brewpub. Born in South Vietnam in 1974, Bui moved to Richmond with two of his older brothers in 1985. Their parents joined them in 1992, and the family opened Mekong, a Vietnamese restaurant, in 1995. Bui began to curate an offering of Belgian beers that complemented the flavors on Mekong's menu. Gradually, he educated patrons about craft beer, and the restaurant's beer list grew to include domestic craft brews. Through those one-on-one interactions, Bui built a loyal customer base for his family's restaurant. At the same time, he was helping the local craft beer industry by educating palates and converting supporters. Encouraged by the growth of Richmond's brewery scene after 2012, Bui opened The Answer Brewpub next door to Mekong in 2014. He's been at it for so long now that he's now serving a second generation of Mekong diners and beer connoisseurs. And his early dream of Richmond becoming "a tiny dot on a beer map one day" has more than come true.

ERIC JACKSON

Eric Jackson is the president and founder of Capsoul Brewing Collective. A lifelong creative and a longtime hospitality professional, Jackson began blogging about beer while working in hotels in Georgia. Once he moved to Richmond in 2019, the blog evolved into Capsoul Collective, a social media business with a mission to cultivate diversity and inclusion in the Richmond beer scene. With a small team, Capsoul soon expanded from a magazine and podcast to a pop-up brewer and event host. They produced Cohesion, a double IPA, to commemorate and encourage unity in Richmond in the midst of the Covid-19 pandemic and the racial reckoning of 2020. At pop-up events and brewery collaboration across the city, Jackson loves to help beer-reluctant drinkers find a style they love. Now, he and the Capsoul team are working to open a brick-and-mortar location. When they do, it will be Richmond's first Black-owned brewery. 🍺

Visit southernfoodways.org to explore the rest of the Tapping into Richmond Beer oral history project, part of SFA's archive of more than 1,000 oral history interviews.

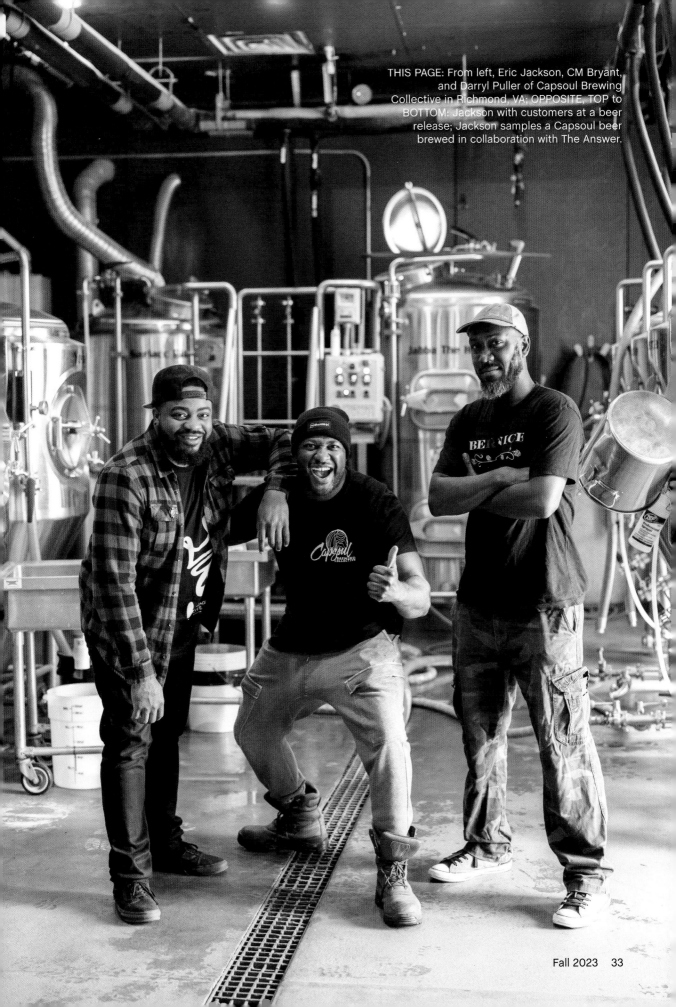

THIS PAGE: From left, Eric Jackson, CM Bryant, and Darryl Puller of Capsoul Brewing Collective in Richmond, VA; OPPOSITE, TOP to BOTTOM: Jackson with customers at a beer release; Jackson samples a Capsoul beer brewed in collaboration with The Answer.

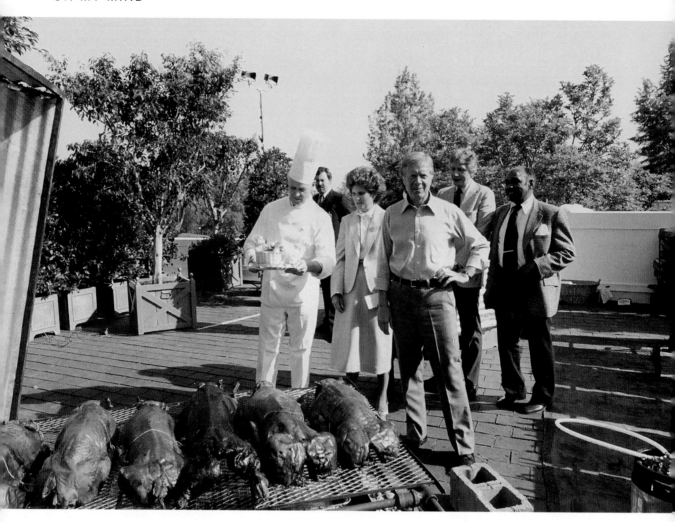

A PLATE FULL OF PLAINS

Home cooking in the Carter White House

BY ADRIAN MILLER

I'VE HAD A COUPLE OF GEORGIANS ON MY MIND OF LATE. IN FEBRUARY 2023, JIMMY Carter, the thirty-ninth president of the United States, announced that he had entered hospice care. At the time of this article, he's still with us at age ninety-eight, and he's the longest-living president in United States history. In August 2023, former First Lady Rosalynn Carter celebrated her ninety-sixth birthday amidst her own health challenges. These two remarkable and resilient people have come to epitomize what a good life, guided by faith and marked by love and service, can be. Going from berated to beloved has been quite a star turn for a president who left office with low approval ratings. The Carters' successful and very public post-presidency "second act" has made the twilight of their lives so meaningful to us today. Since leaving the White House, President Carter continued to champion human rights, mediate international disputes, build houses with Habitat for Humanity International, author several books, and teach Sunday School at Maranatha Baptist Church in Plains, Georgia.

I was a child during President Carter's tenure, but I still have vivid memories of his infectious smile, the slight drawl of his Southern accent, and a sense that he was trying to do the right thing. I also remember the serious headwinds he faced: inflation, long gas lines, and the Iran hostage crisis. Decades later, a visit to the Jimmy Carter Library and Museum in Atlanta, Georgia, renewed my interest in his administration. I was there to research African American presidential cooks. I wasn't interested in how President Carter met the policy challenges of his term; I just wanted to know what he ate. I fully expected to review the same information that I'd found in other presidential archives, namely state dinner menus and maybe a few recipes. I was delighted to find much more: a treasure trove of hundreds of private dinner menus in the executive residence. It's a food nerd's dream, and one that rarely comes true—whether for privacy reasons or perceptions of historical insignificance, such menus are seldom archived.

The American public tends to demand the impossible from its presidents. We want them to be exceptional people, but we also want them to be a lot like us. During campaigns, voters crave ways to connect with the person who might lead the nation, and food has often proved to be an effective window into the presidential soul. A politician who is knowledgeable about, and prefers, so-called "traditional" American foods makes a strong case for having "the common touch." Of course, there are nearly as many American diets as there are Americans. Even so, an elected official's choice to eat foods generally regarded to be old-fashioned, patriotic, or humble tends to instill confidence that the nation is in good hands.

Carter tapped into this sentiment by playing up his roots as a peanut farmer and a country-food-loving family man. In a widely syndicated March 1976 column, then-candidate Carter told *The Washington Post*'s Sally Quinn that, at home in Plains, Georgia, he and Rosalynn shared cooking duties. "We divide the responsibility," Carter said. "I'm a fairly good cook. I like Southern foods, corn on the cob, collard greens and turnips, grits, fried chicken. I like plain food." Those sentiments certainly work on the campaign trail.

Just as the Nixons and Fords had done, the Carters put White House Executive Chef Henry Haller in charge of all family and guest meals in the executive residence. Swiss-born Chef Haller cooked for President Johnson for a few years, but the family dinners were prepared by an African American cook from the Johnsons' native Texas named Zephyr Wright. Some suspected the Carters would bring a family cook to ensure the consistency of the Southern specialties they loved. That never happened. When the First Family traveled away from the White House, such as to Camp David, the culinary team in the US Navy–run White House Mess handled food operations.

LEFT: President Jimmy Carter with White House social secretary Gretchen Poston and executive chef Henry Haller as they inspect preparations for a state dinner in honor of Prime Minister Masayoshi Ōhira of Japan, May 2, 1979. The menu featured barbecue suckling pig to satisfy Ōhira's interest in tasting traditional American cuisine.

THE CARTERS ENTERED the White House amid a swirl of food trends. In the 1970s, salad as a first course or entrée was in vogue as a healthy and economical choice. First Lady Rosalynn Carter was in step with this trend by writing a salad-centric memo for the culinary staff on stationery with an ABOARD AIR FORCE ONE header:

"M—

There are several salads that Jimmy
 prefers. Please tell Ron [Jackson]
 (Also Henry Haller)

* Spinach and mushroom
1. Tossed salad & bleu cheese dressing
2. Avocado & grapefruit
3. Caesar salad
4. Pear salad & grated cheese &
 a dash of mayonnaise
5. Congealed salad with mayonnaise
6. Cole slaw
7. Carrot & raisin

RBC doesn't like heart of palm
JC does not like cranberries
JC does not like thousand island
[dressing]"

We may be turned off today by some of those
favorites, but copious amounts of congealed
salad and mounds of mayonnaise were mid-
century staples that survived into the Carter
era and beyond.

The Carters' very first presidential Thanksgiv-
ing on November 24, 1977, had a bit of Southern
influence. Ron Jackson, the White House Mess
food-service coordinator, proposed a classic
Thanksgiving menu that included turkey, corn-
bread dressing, sweet potatoes, cranberry sauce,
and more, and invited the First Lady's feedback.
She crossed out "Whipped Potatoes" and "Green
Peas w/ Mushrooms," suggesting fresh (not fro-
zen) green beans in their place. "Jimmy doesn't
especially like green peas," she wrote.

After the Immigration and Nationality Act of
1965, the United States opened its borders to
waves of immigrants. Many opened restaurants
that introduced the cuisines of their homelands
to their new neighbors. In time, Americans pa-
tronized these restaurants and embraced their
fare. As Americans of many backgrounds became
more comfortable with newly arrived cuisines—
Chinese, in particular—cookbooks and television
cooking shows encouraged them to try making
some of those dishes at home. On April 11, 1978,
the Carters' dinner menu reflected how ubiqui-
tous certain dishes had become: chicken chop
suey, egg rolls with shrimp, and steamed rice.
Egg foo yong and chow mein weren't on the list

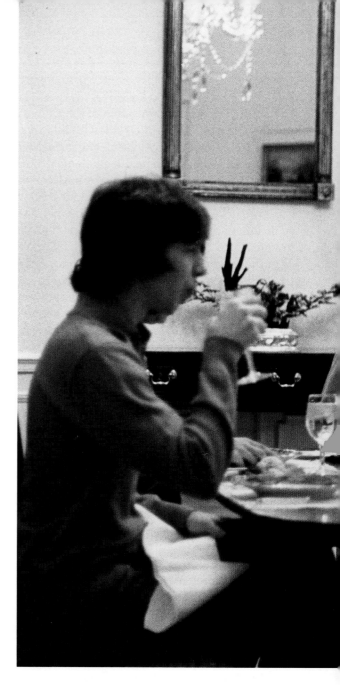

The First Lady crossed
out "Whipped Potatoes
and "Green Peas w/
Mushrooms," and added,
"Jimmy doesn't especially
like green peas."

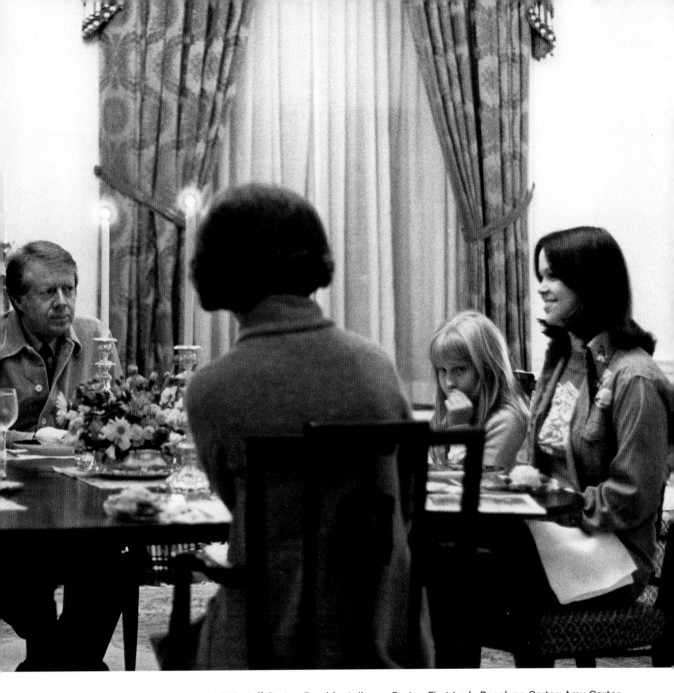

FROM LEFT: Jeff Carter, President Jimmy Carter, First Lady Rosalynn Carter, Amy Carter, and Annette Davis Carter dine in the White House on February 22, 1977.

that night, but they popped up on other menus.

Even as the first family's diet reflected a national trend toward palate-broadening, Southern staples were ever-present on their White House table. The Carters incorporated dishes such as ambrosia, cheese straws, and spoonbread, believed to be derived from an Indigenous American dish. Then there was the Friday-night fish dinner, a tradition in many pockets of the South. It's usually a humble meal, but by being prepared and served at 1600 Pennsylvania Avenue on White House china, even a simple cornmeal- or flour-dusted

fish must have felt elevated. The Friday, September 26, 1977, menu was a classic: "Southern Fried Fish, French Fries, Hush Puppies, Coleslaw." Sometimes White House chefs varied the preparation and type of fish. For example, on Friday, July 4, 1980, the Carters dined on: "Broiled Filet of Trout, Fried Eggplants, Broccoli Spears, Mixed Green Salad w/ Bleucheese (sic) Dressing." Even though barbecue is a Fourth of July mainstay, the Carters' devotion to fish was unwavering. An avid fly fisherman, Carter loved to catch trout, though there's no evidence he supplied the catch for that

Independence Day dinner.

Weekend barbecues were also a fixture of the Carter White House. The standard menu included pork spareribs, potato salad, and coleslaw. Other times, the barbecue was chicken or chopped pork. On Saturday, March 11, 1978, things got a little weird when it came to the barbecue side dishes. Next to the ribs were pearl onions, boiled green cabbage, cornbread, and fresh pear salad.

The ritual of smoking and grilling meat also played a tiny role in diplomacy. According to a *Washington Post* story that carried the headline "Barbecue Diplomacy," after trade negotiations broke down with Japan, the Carters hosted an elaborate West Terrace barbecue for Japanese Prime Minister Masayoshi Ōhira on May 2, 1979. The menu consisted of barbecue chicken, suckling pig, and—wait for it—buffalo. Passersby could smell the wafting smoke for blocks. Carter is quoted as toasting Ōhira that evening, saying the day was "one of the most productive days in my whole diplomatic life." Ōhira was quoted as

Jec (handwritten signature)

17 NOVEMBER 1977

MEMORANDUM FOR: MADELINE MacBEAN

FROM: RON JACKSON *Ron* (handwritten)

SUBJECT: Proposed Menu
 Thanksgiving Day Dinner
 Aspen Lodge, Camp David
 24 November 1977

Following is our proposed menu for Thanksgiving Day Dinner at Camp David. Would you please add, delete or make any other changes that will help us to make this a perfect Thanksgiving for the First Family.

who?
When will eat? (handwritten)

Thank you.

Roast Turkey

Cornbread Dressing

Candied Sweet Potatoes

~~Whipped Potatoes~~

Natural Turkey Gravy

Jimmy doesn't especially like green peas. (handwritten) ~~Green Peas w/ Mushrooms~~ *fresh green beans (but not frozen ones)* (handwritten)

Fresh Cranberry Sauce

Waldorf Salad

Rolls - butter

Pumpkin Pie w/ Whipped Cream

Coffee - Tea - Milk

saying the buffalo was "a little coarse."

Additional menus offer a sense of how the Carters were nourished during the administration's other big moments. Though I did not see menus from the summit between Egyptian and Israeli leaders that led to the Camp David Accords, I did find clues as to what President Carter ate in the early days of his biggest challenge: the Iran hostage crisis. On November 4, 1979, militants seized the United States Embassy in Tehran and took fifty-two people hostage. That week, the Carters ate dinners featuring broiled tenderloin tips, coquille of crabmeat, stuffed saddle of lamb, and egg foo yong with Shrimp. An eclectic mix for sure, but the meal served on Wednesday, November 7, is noteworthy. The menu included fried chicken, hot biscuits, butternut squash, braised lettuce, Waldorf salad, and dessert by request.

I'm guessing that this taste of home brought much-needed comfort to the Carters and sustained them during an extremely stressful situation.

Fish fries and barbecues have long been political campaign mainstays. On August 7, 1980, just a week before President Carter accepted his second nomination for president at the Democratic National Convention in New York, the First Couple hosted a barbecue at the White House. The event was intended as a thank-you to Carter's supporters, but in retrospect it served as an unintentional farewell. Traditional pits were dug on the White House South Lawn, and tables groaned with smoked pork, Brunswick stew, potato salad, rolls, sweet pickles, and strawberry cobbler. As election day drew near and campaigning more intense, the comfort of familiar foods is suggested in the menu for Thursday, September 4, 1980: "Soft Fried Country Ham, Red Eye Gravy, Grits, Collard Greens, Cornbread, Lettuce and Tomato Salad."

Two months later, Carter would lose his re-election bid to Ronald Reagan. With the inauguration of the fortieth president three weeks away, and the Carters' time in the White House virtually at

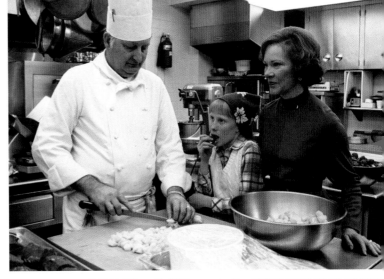

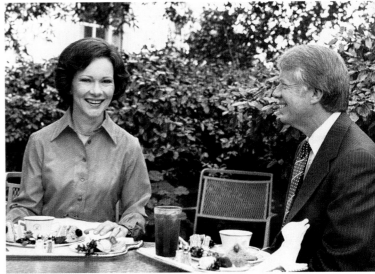

TOP TO BOTTOM: Chef Hans Raffert, Amy Carter, and Rosalynn Carter in the White House kitchen, January 24, 1980; First Lady Rosalynn Carter and President Jimmy Carter have lunch on the White House patio, August 4, 1977.

an end, on Wednesday, December 31, 1980, menu spoke lovingly of Plains, where it all began: fried chicken, hot biscuits, mustard greens, yellow turnips, and coleslaw. Desserts were served on request; perhaps they included pecan pie or even pound cake, stars of the Southern larder at that time of year.

This is just a taste of the Carters' White House diet. It does make me wonder what the former first couple is eating now; if the same foods that sustained them all those years are nourishing them now in the twilight of their lives. And if, every now and then on a Friday, someone fries up a tray of fish for them and their loved ones. ❦

Adrian Miller is a former White House staffer and author of The President's Kitchen Cabinet: The Story of the African Americans Who Have Fed Our First Families from the Washingtons to the Obamas.

The Right Stuff

In northwestern Louisiana,
a stuffed-shrimp scion rolls with the punches.
*by **Chris Jay***

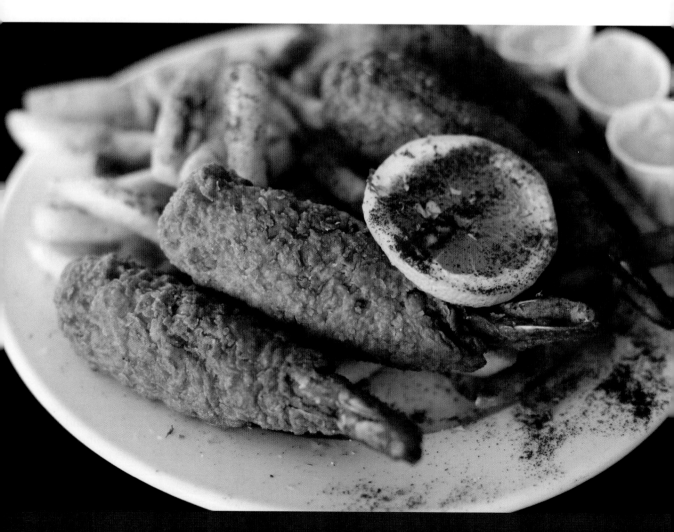

THIS PAGE: Damien "Chapeaux" Chapman owns and operates Orlandeaux's Café in Shreveport, LA. OPPOSITE: A plate of Orlandeaux's stuffed shrimp with french fries and tartar sauce

Chapeaux Chapman's mind was made up.

All morning long, the thirty-three-year-old chef and owner of Orlandeaux's Cross Lake Café in Shreveport, Louisiana, had been mulling over a situation involving an employee that he'd hired a few weeks earlier—a rough-around-the-edges twenty-three-year-old named Jerry, the son of another kitchen worker named Jerry. Since the younger Jerry didn't use the suffix "Jr.," everyone in the restaurant quickly took to calling the father-son duo Big Jerry and Little Jerry. Chapeaux assigned Little Jerry to the deep fryer, the busiest station in the kitchen of a restaurant known for fried seafood. The young man was still struggling to adapt to the pressures of his new job when Big Jerry approached Chapeaux, hat in hand.

"My son's not a cook," the older man said firmly. "You need to put him on dishes."

"Mr. Jerry, he's a troubled kid. Give him a chance," Chapeaux pleaded. "You were once there. You never know what he can do."

Chapeaux promised Big Jerry that he'd consider the suggestion, but something about the idea of reassigning the young man didn't feel right.

With his square jaw, broad shoulders, and slight but athletic build, Chapeaux could be a welterweight boxer. His brow is often furrowed with concern for a line cook who hasn't shown up yet, a batch of tartar sauce that needs to be made, or the details of an upcoming party in the restaurant's perpetually booked second-floor ballroom. Since Chapeaux converted from Protestantism to Catholicism in 2017—a step that he took in order to feel closer to his Cane River Creole ancestors—a silver St. Christopher medallion has dangled from a thin chain around his neck. He almost always wears a fitted New Orleans Saints ball cap which, when turned backwards, signals to members of his seventy-person staff that he is hyperfocused on whatever task is at hand.

Chapeaux spent the October morning paying vendors and running payroll before climbing a rickety ladder onto the gabled rooftop of Orlandeaux's to hang Christmas lights. He paused briefly to watch some of the year's first white pelicans arriving on Cross Lake. They come each fall, hundreds at a time, an incredible sight. A Black family with two young children stood on the point in front of Orlandeaux's, looking out at the water and the birds.

For many years, the building beneath Chapeaux's feet housed a whites-only restaurant called Smith's Cross Lake Inn. Long after the official end of segregation, Smith's clientele remained nearly all white; its waitstaff all Black. Chapeaux's paternal grandfather, Willie "Brother" Chapman, cooked at Smith's in the 1950s while also cooking at his family's restaurant, Freeman & Harris Café. One of the first things Chapeaux did after purchasing the sprawling lakefront restaurant in 2021 was to hang an oversized portrait of Brother, who passed away in 2003, in the restaurant's foyer. Brother smiles out from the fading photo, ebullient, as if the photographer captured him mid-laugh.

Throughout the morning, Chapeaux considered Big Jerry's request, but he knew all along that he would not reassign Little Jerry to a less-challenging station. Perhaps, Chapeaux thought, the young man had entreated his father to request the

change. Maybe a challenge was just what Little Jerry needed. The tough part would be delivering his verdict to Big Jerry.

Big Jerry is a stuffed shrimp roller at Orlandeaux's, which places him among an elite inner circle of employees who are entrusted to produce the restaurant's most popular menu item. Chapeaux's great-grandfather, Arthur "Scrap" Chapman, taught Big Jerry to roll before Chapeaux was born. It would be tough for Chapeaux to say "no" to someone who'd rolled stuffed shrimp for his great-grandfather, but he would find a way. Chapeaux navigates the complicated hierarchy of Shreveport stuffed shrimp every day of his life.

"I'm going to stick him on the fire," Chapeaux would later tell Big Jerry. "I'm gonna tell him when to drop [the fry basket]. I'm gonna tell him when to pick it up." Little Jerry might be overwhelmed at first, but Chapeaux trusted he'd get the hang of it.

To roll—a term of art in Shreveport restaurants like Orlandeaux's—is to clean and butterfly large shrimp, stuff them with a Creole-style crabmeat dressing, chill them, dredge them in a thick, spicy batter made from crumbled cornbread, and shape them into oblong torpedoes using a cupped palm. After an egg wash and a dunk in the deep fryer, they emerge looking more like corn dogs than fried shrimp. Stuffed shrimp rollers are respected not only because rolling is a lengthy and difficult process, but also because the practice has traditionally been passed down from one generation of stuffed shrimp cooks to the next. Not just anyone can become a roller; for more than half a century, it has been seen as an honor to be taught. At least that's how it used to be.

Chapeaux recently saw something that shook him up: An anonymous user posted a video to YouTube showing how to roll stuffed shrimp using his family's techniques. Chapeaux's late father, Orlando Chapman—a towering, mustachioed man who was known to sport an old-fashioned chef's toque while cooking—always told him that only family members should be allowed to see the rolling process from start to finish. Chef Orlando, as he was known, would go so far as to clear the kitchen of his restaurant, Brother's Seafood, whenever he settled in to roll stuffed shrimp or to make the restaurant's tartar sauce, a beloved condiment more akin to New Orleans–style remoulade. Now anyone with an internet connection could see how it was done.

Chris Jay

Chapeaux Chapman visits with a customer at Orlandeaux's, October 2022.

"I tell people all the time: You can have the exact recipe, the exact procedure, but it'll never taste the same [as ours]," Chapeaux said, anger and betrayal audible in his voice.

Was he worried that other restaurants would watch the video and attempt to duplicate his family's recipe and process?

It's not even just other restaurants, Chapeaux said. "There's a dozen people who are, right now, making this style of stuffed shrimp at their houses and selling them on the streets of Shreveport. And their claim to fame is that my father or my grandfather taught them how."

He pointed to a platter of four golden-brown stuffed shrimp on the table in front of him. They almost seemed to glow.

"This is gold to people," he said.

By the time stuffed shrimp appeared on the menu of Freeman & Harris Café in the late 1950s, the restaurant named for two of Chapeaux Chapman's ancestors had been in business for more than thirty years. It was founded in the early 1920s

by Van B. Freeman Jr., who was soon joined in the endeavor by first cousin Jack Harris. Both men moved from the rural community of Campti, Louisiana, to the then-booming city of Shreveport, seventy miles to the north, sometime between 1910 and 1920. Their move was part of a demographic shift taking place in cities across America during the early years of the Great Migration, when many people of color moved out of the South altogether and others relocated from the countryside to urban centers in search of happier, safer lives.

The first home of Freeman & Harris Café was a tiny stall on "the Avenue," a bustling district of minority-owned businesses on the western edge of downtown Shreveport. Along the Avenue, which stretched for five large city blocks, Shreveport's marginalized populations could patronize doctors, lawyers, grocers, and barbers by day and could dance, drink, and dine by night. In addition to numerous Black-owned entertainment venues, a Black-owned newspaper, *The Shreveport Sun*, made its headquarters on the Avenue. Artists like Jelly Roll Morton and Count Basie were among the touring entertainers who performed next door to Freeman & Harris Café among the rooftop gardens of the Calanthean Temple, a four-story office building owned by a Black women's organization called The Grand Court Order of Calanthe. The city's first Chinese restaurant, Canton Café, was located on the Avenue, as well as the first few locations of a long-running, Jewish-owned chain of liquor stores called Cuban Liquor. Business at Freeman & Harris was brisk, and the café eventually outgrew its small, shared storefront on the Avenue. In 1936 the restaurant moved into a larger space in the historically Black neighborhood of Allendale, where it would function as a central hub of social life for sixty years.

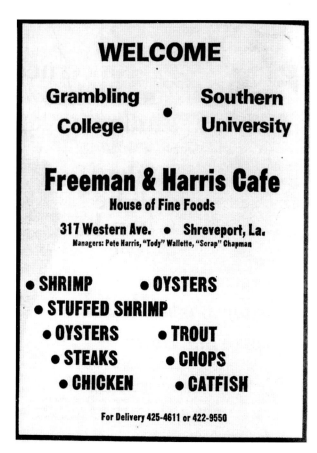

TOP and BOTTOM: Orlandeaux's displays memorabilia from Freeman & Harris Café, the first Shreveport restaurant to serve stuffed shrimp.

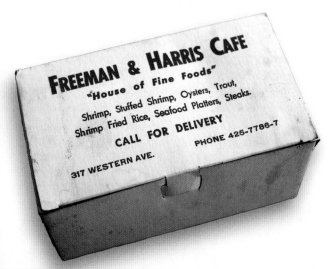

Van B. Freeman Jr. passed away in 1947. Jack Harris continued to run Freeman & Harris Café with the help of three younger relatives, all of whom had worked in the family business: Harris' nephews Arthur "Scrap" Chapman and Pete Harris, and Freeman's nephew Wilmer "Tody" Wallette. The youthful influence brought changes to Freeman & Harris Café in the years that followed. Some of those changes were small but meaningful adjustments, such as manager Pete Harris' decision to change the restaurant's slogan from "House of Good Foods" to "House of Fine Foods" in 1957, telegraphing a more sophisticated sensibility. Other were more dramatic.

The boldest of these reforms, according to local lore and written histories of Shreveport, was that Freeman & Harris Café began seating white customers and Black customers together in the same dining room in the fifties, making it the city's first integrated restaurant. Whether or not this is true, it has been repeated often enough to find its way into history books. In his

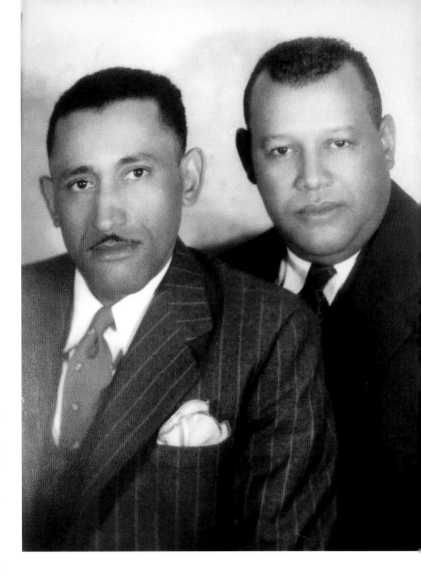

From left: Chapeaux Chapman's grandfather Arthur "Scrap" Chapman with Freeman & Harris Café cofounder Jack Harris

book *Shreveport*, local historian Eric Brock wrote that "Freeman & Harris Café became the first to offer equal seating to white customers as well as [B]lacks." The idea that a Black-owned restaurant could "offer equal seating to white customers" in the Jim Crow South inverts the racist dynamic being addressed by the Civil Rights Movement and desegregation: white-owned businesses refusing equal service to Black patrons. No laws ever governed where white diners could or could not eat. Freeman & Harris Café would not have had legal standing to refuse service to white customers, but that hasn't prevented the local spread of the belief that Freeman & Harris Café integrated its dining room a decade prior to the passage of the Civil Rights Act of 1964.

Freeman & Harris Café's signature stuffed shrimp likely debuted during the holiday season of 1958, when weekly advertisements for the restaurant in *The Shreveport Sun* first mentioned the new house specialty. There are several competing accounts of the recipe's origin and creators. One version of events proposes that longtime restaurant manager Pete Harris brought the idea for the dish back from a vacation in Galveston, enlisting kitchen leadership to help recreate what he'd eaten at a Black-owned seafood restaurant there called Jambalaya Café. Pete Harris did not cook, so the effort to reverse-engineer Jambalaya Café's stuffed shrimp—which began appearing in Galveston newspaper ads in the early 1950s—would have been collaborative by necessity. Another account suggests that the recipe was singlehandedly created by longtime Freeman & Harris cook Eddie Hughes. Still other versions credit second-generation co-owner Tody Wallette or Chapeaux's grandfather Brother Chapman with inventing the dish.

One thing is certain: Stuffed shrimp was a hit.

As decades passed and awareness of this local delicacy grew, several well-known Freeman & Harris Café chefs departed to open their own competing restaurants. Following the 1976 death of Tody Wallette, who had raised him as a father, Eddie Hughes parted ways with Freeman & Harris Café to open Eddie's Restaurant in 1978. Connie Robinson, a longtime stuffed shrimp roller for Freeman & Harris, went on to open C & C Café. The 1992 death of Pete Harris triggered the departure of several key Freeman & Harris Café staffers, who opened Pete Harris Café as a tribute to their mentor in 1993. Chapeaux's father, Orlando Chapman, cooked at Pete Harris Café until he departed to open Brother's Seafood following Brother Chapman's death in 2003. In this way, what began as the house specialty of a single Shreveport restaurant proliferated into a citywide food tradition. Chapeaux sees Orlandeaux's as a direct descendant of Freeman & Harris Café, and himself as its fifth-generation keeper of the flame.

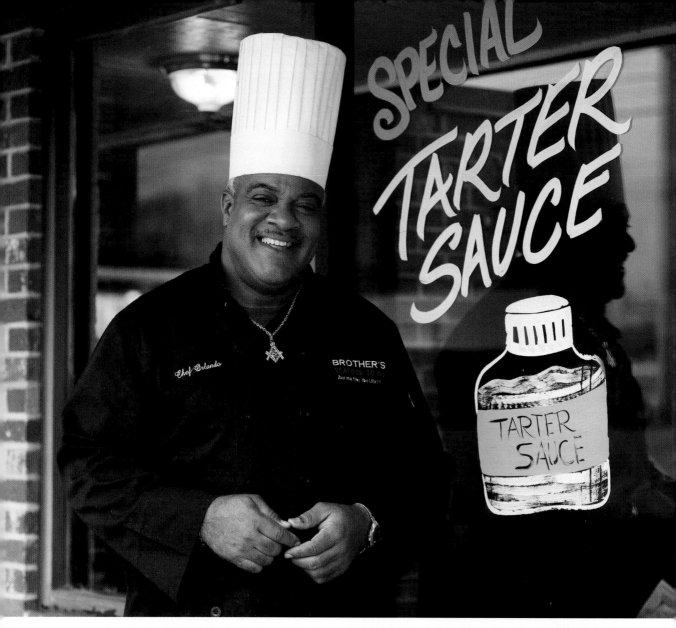

THIS PAGE: Chef Orlando Chapman opened Brother's Seafood in 2004. He passed away in 2013.
RIGHT: A remoulade-like style of tartar sauce is the preferred condiment for Shreveport stuffed shrimp.

It was 10:55 A.M. when Chapeaux climbed down from the roof in full view of the large crowd that milled about waiting for him to unlock the restaurant's front door. Chapeaux does not allow anyone else to unlock the door; it is a ritual he keeps for himself. As he made his way through the crowd, many customers greeted Chapeaux by name or ribbed him for hanging his own Christmas lights instead of having an employee do it. Every move he makes at the restaurant is public, and even his most insignificant choices are likely to attract commentary. Stone-faced, Chapeaux turned his Saints cap backwards and slipped the key into the lock. As the first of three Friday lunch crowds shuffled past Brother Chapman's

portrait into the sunny, sprawling dining room, they were met by the scents that have followed five generations of Chapman men home from work late at night, six nights a week: catfish bubbling in clean oil, sweet cornbread rising in the ovens, blue-crab meat simmering in a secret mirepoix.

Maybe Chapeaux recognized Little Jerry's plight. The awkward twenty-three-year-old had been dropped suddenly, like a basket of stuffed shrimp into hot oil, into the fragile clockwork of a busy restaurant kitchen with a century-long reputation to uphold. Maybe Chapeaux thought back to that horrible day—Tuesday, September 24, 2013—when he suddenly became the sole

THIS PAGE: Jim Noetzel; OPPOSITE: Chris Jay

steward of the family business. That afternoon, while Chapeaux was attending a training session in Dallas, his forty-nine-year-old father suffered a fatal heart attack while boating on Cross Lake. When he received the news, Chapeaux was a twenty-four-year-old oilfield engineer who had not yet learned the ropes of the family business. He thought there was still plenty of time. Maybe Chapeaux refused Big Jerry's request because he wished that someone had come along and forced him into the kitchen alongside his own father before it was too late.

"I'm thirty-three now, and I've got people who work here for us who are double or even triple my age," Chapeaux said. "They saw me when I was a kid, running around the place, and as a teenager playing around when my dad wasn't looking. Now I'm in this role of having to tell them what to do and how to do it. It can be challenging for them sometimes to call me 'Boss.'"

When he feels overwhelmed by the more challenging aspects of his new role, Chapeaux calls on four generations of Chapman men who were called "Boss" before him. When he requires confidence in the kitchen, Chapeaux leans on his grandfather Brother. For the strength to address employee behavior, he turns to the spirit of his father, Chef Orlando, a notoriously vigilant taskmaster. When he needs to deal with a disorderly or combative guest in the restaurant's bar, he summons the spirit of the man he called "Paw-Paw Scrap," who was given his nickname due to a raw talent for brawling.

"I don't act like that on a normal basis, in my regular persona," Chapeaux said. "But when I have to be stern and put somebody out, I'm Scrap. He comes through."

People don't change when they're comfortable. People change when someone sticks them on the fire and leaves them there. They may panic, squirm, and cry out for relief. They may curse their new burdens, but they have to be left there on the fire in order to become the person they are meant to be. They may not know what they're doing at first, but once they've done it more and more, they understand. 🏆

After many years in Shreveport, Chris Jay now lives in Round Rock, Texas. He is a new father and an enthusiastic thrifter.

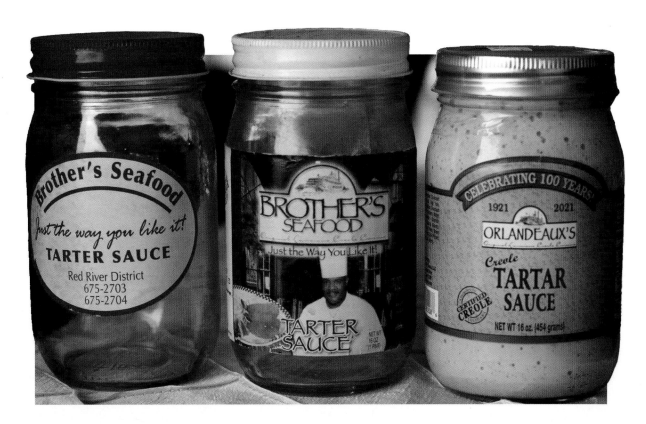

ANNIE FISHER

Eighty-five years after her death, a culinary entrepreneur's success story still resonates.

by MACKENZIE MARTIN

BISCUIT QUEEN *of* MISSOURI

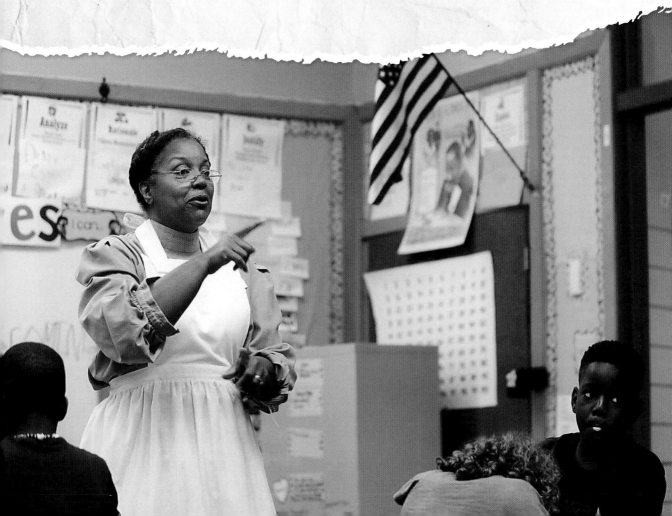

BACK IN THE NINETEENTH CENTURY, before commercial leaveners like baking powder were ubiquitous, cooks had to put in some serious elbow grease if they wanted their quick breads to rise in the oven.

One of the most laborious recipes of the era was the beaten biscuit. These tender, flaky hardtack rolls, not much thicker than a cracker, were often made by enslaved cooks and domestic servants. A cook might spend as much as an hour creating delicate layers in the dough by whacking it with anything from a rolling pin to an ax handle.

At the turn of the twentieth century, the most famous beaten biscuits in Columbia, Missouri, were those made by culinary entrepreneur Annie Fisher. Serving her beaten biscuits at a party or dinner was a major hostess flex.

Clement Richardson, editor of the *National Cyclopedia of the Colored Race*, wrote in 1922, "It is possible that many people in Missouri can make beaten biscuit, but none of them are Ann[ie] Fisher's biscuit."

These days, the kind of success that Annie Fisher enjoyed might be attributed to an impressive marketing plan, investors, or, at the very least, access to a bank loan.

But as a Black woman in Jim Crow Missouri, Fisher was essentially denied access to those advantages. Yet she amassed a fortune anyway.

"That's the miracle of the whole situation. That woman had every opportunity to fail—and didn't," says Columbia, Missouri, resident Verna Laboy.

Laboy, who began her side project in historical reenactment more or less on a whim, has spent much of the last thirty years piecing together how Fisher did it. It's largely thanks to her work, with additional research by a handful of Missouri historians and journalists, that we have a snapshot of Annie Fisher's life.

In the 1990s, when Verna Laboy was a recent transplant to Columbia, she heard that the Boone County Historical Society needed reenactors for its annual Hall of Fame induction gala. Laboy didn't have professional acting experience, but as a self-professed "drama queen," she volunteered to play Annie Fisher, one of that year's Hall of Fame inductees. To prepare for the role, Laboy started interviewing community members to learn more about Fisher, who passed away in 1938. And she didn't stop after the gala. She was hooked.

"It's almost like her story captivated my soul," she says.

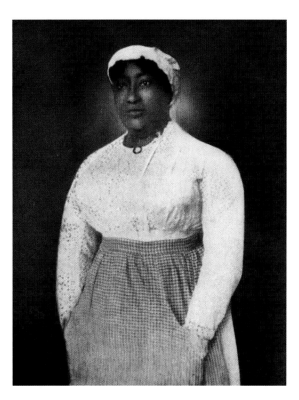

ABOVE: Annie Fisher, ca. 1916; OPPOSITE: Verna Laboy, dressed as Annie Fisher, presents to students at West Boulevard Elementary School in Columbia, MO, 2017.

Though she works full-time in public health, Laboy has been giving historical presentations about Annie Fisher ever since. Laboy's telling of Fisher's story evolves as she learns new information.

Laboy says it's important to her, as a Black woman, that young people know who Annie Fisher was. In school, she says, they learn about slavery and Jim Crow. Fisher's story—that of a Black businesswoman who ran a wildly successful catering enterprise mostly on her own—adds triumphant complexity to those narratives. That's why Laboy takes vacation time from her day job to present at school assemblies. She wants to push her audience to dream big, like Fisher did.

ANNIE KNOWLES FISHER WAS BORN into a large family in Boone County, Missouri, in 1867. Her parents, Robert and Charlotte Knowles, were born into slavery.

Fisher developed a love of cooking while taking

care of children in white homes, when she was not much older than a child herself.

"Oftentimes, when the baby was asleep, I would steal down in the kitchen, climb up on a stool and help the cook peel potatoes, and make biscuits," Fisher told the National Negro Business League in 1919. "Sometimes they were not altogether right, and no matter if, at times, they were only half-baked, I enjoyed them very much, for those biscuits were the product of my own hands."

Fisher went on to cook at the Sigma Alpha Epsilon fraternity house at the University of Missouri and in some of Columbia's wealthiest households.

One day, around the turn of the century, her white employer asked, "Annie, why don't you go into the catering business?"

"I began to think seriously over the idea and became convinced that it would pay very well if I could get her support and the trade of her friends. She told me that if I started such a business she would try and induce the society people and the church people to help me with their patronage," Fisher reflected later.

The catering operation began small, with just hot rolls at first. Then she added pies, cakes, and her eventual claim to fame: beaten biscuits.

Described as "fluffy, flaky, and creamy," Fisher initially sold her beaten biscuits for just ten cents a dozen—about three dollars today. She rounded out her menu offerings with dishes like chipped potatoes, fruitcake, roast chicken, salads, and ice cream.

"It was not a party of any status if Annie Fisher wasn't cooking," says Laboy. "People changed their wedding dates, their debutante party dates, so that Annie could accommodate them."

Word of Fisher's catering prowess spread beyond Columbia. Her biscuits were even on the table in 1911 when President William Taft visited the Missouri State Fair in Sedalia, some sixty-five miles away.

Missouri historian Bridget Haney says there were unquestionably other Black female cooks in Columbia at this time, but Fisher seems to have been in a league of her own.

Haney speculates the cornerstone of Fisher's success was indeed talent. There may have been other women who could make biscuits as flaky and delectable as hers, but what gave Fisher an edge was visibility. Glowing press and old-fashioned word-of-mouth recommendations boosted sales. But for a Black woman operating in a segregated world, there were also racial politics and

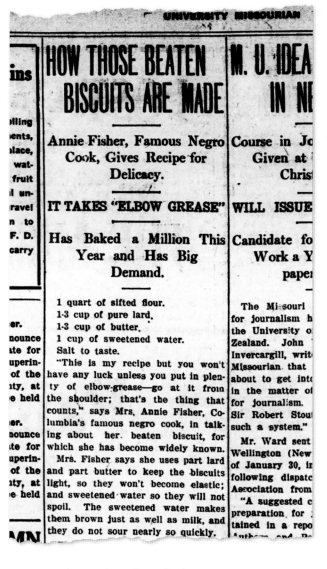

ABOVE: A clipping from the *Columbia Missourian*, Friday, March 17, 1911; OPPOSITE: Donna Battle Pierce's beaten biscuits

social norms to navigate. Among white patrons, Fisher developed a reputation for respectability, a highly racialized form of endorsement.

Fisher didn't guard her recipe for beaten biscuits, but she joked to reporters that what couldn't be taught was the "common sense" needed to make them properly.

To celebrate her growing success, Fisher designed a fourteen-room mansion for herself near Sharp End, Columbia's Black business district, and monitored its construction from a tent she'd staked on the lawn.

Fisher was married to a reverend briefly, but according to newspaper reports, *she* filed for divorce and offered her husband a cash settlement not to contest it—exceedingly rare in those days.

Fisher didn't guard her recipe for beaten biscuits, but she joked to reporters that what couldn't be taught was the "common sense" needed to make them properly.

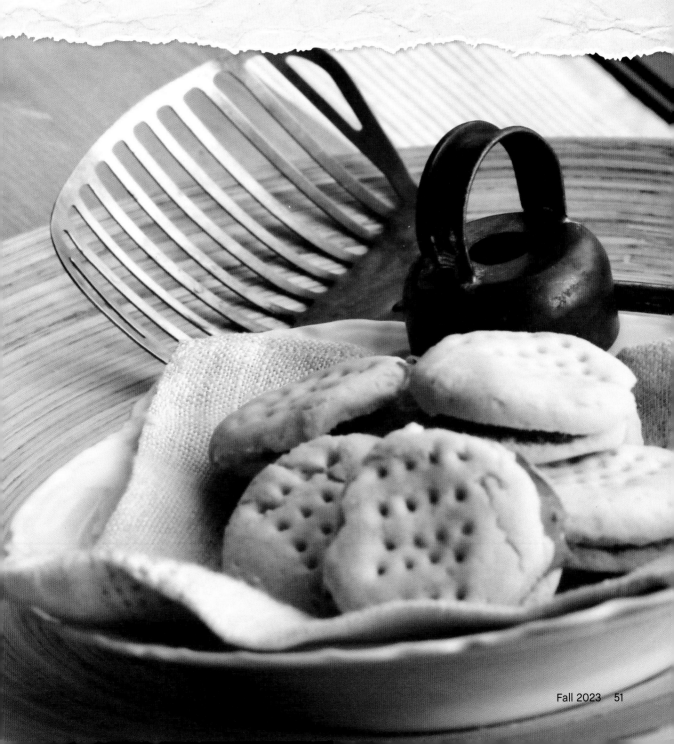

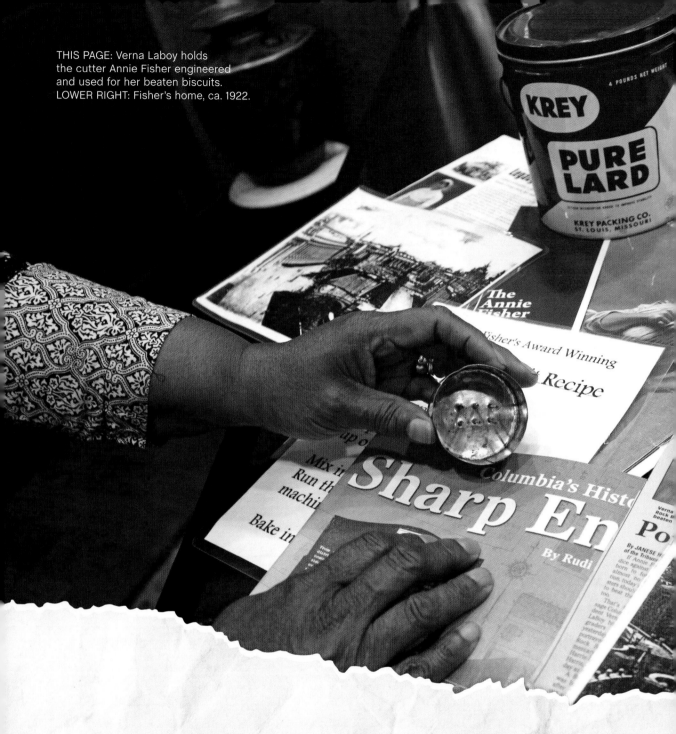

THIS PAGE: Verna Laboy holds the cutter Annie Fisher engineered and used for her beaten biscuits.
LOWER RIGHT: Fisher's home, ca. 1922.

"She's a smart woman, this Annie Fisher. She's a specialist in two kinds of dough—the kind that makes beaten biscuits and the kind that swells a bank account," wrote a reporter for the *St. Louis Globe-Democrat* in 1927.

Throughout the 1920s, she regularly catered for parties with guest lists in the hundreds while simultaneously running a successful mail-order business. Her daughter, Lucille Smith Merritt, was her only assistant. Hollywood celebrities and New York City stockbrokers were reportedly among those who ordered Fisher's beaten biscuits by mail.

"She's a smart woman, this Annie Fisher. She's a specialist in two kinds of dough—the kind that makes beaten biscuits and the kind that swells a bank account," wrote a reporter for the *St. Louis Globe-Democrat* in 1927.

By 1926, at age fifty-eight, Annie Fisher had made more than enough money to retire. Instead, she opened her first restaurant. Fisher built the Wayside Inn—a grand, two-story house—on a farm where her parents had lived, just outside of Columbia. Inside, the floors were polished and the decor included elegant rugs, mahogany furniture, and leather upholstery. Fisher resided in one of the house's many bedrooms. The restaurant, which specialized in chicken dinners, was well patronized by a white clientele. And their hostess expected guests to behave themselves. Fisher's minister had sprinkled the house with holy water, and liquor and dancing were strictly forbidden.

"People can't get common around here," she told the *Globe-Democrat*. "When they comes to Annie Fisher's they comes to eat, and if they want to do any high-ballin' they must do it before they come and after they leave."

Admittedly, it *was* the height of Prohibition.

PART OF THE MYSTIQUE OF ANNIE Fisher, then and now, is how tight-lipped she was about her success. Nosy people always asked how much money she had, but she was coy. She'd only ever say something along the lines of having done pretty well for herself.

In 1929, it was estimated that her fortune was worth $150,000, which is nearly three million dollars today. It wasn't just biscuit money lining her pockets, either. She also became something of a real estate mogul. In addition to her two mansions, she owned more than a dozen smaller houses in Columbia as rental properties, during a time when it was notoriously difficult for Black Americans to purchase homes.

Fisher's success is all the more extraordinary given the open bigotry that was so prevalent at the time. Just a few years earlier, in 1923, James T. Scott was lynched by a mob in Columbia. Scott, a Black man, was falsely accused of assaulting a white girl.

"Long ago, I got the idea that the only way I could ever get ahead was to believe in myself and not the other fellow," Fisher said to the *Globe-Democrat*. "For that reason, I never tell anyone my business.... I live honest and I try to make the most of the opportunities I have."

Fisher only received a third-grade education, but she put her daughter through college and a music conservatory with her catering profits.

"Painful things happened and something beautiful came out of it. And I think that's the way life happens for a lot of us," says Verna Laboy.

Aside from the Boone County Hall of Fame induction that introduced Verna Laboy to Annie Fisher, Fisher's story essentially vanished after her death in 1938 at the age of seventy. Her daughter reportedly had no children of her own. When Laboy found one of Fisher's indirect descendants in Columbia, she was crestfallen to learn the relative knew nothing about Fisher.

In recent years, Columbia has done more to recognize Fisher. One of the local food pantries is now

Verna Laboy demonstrates how to use a biscuit brake like the one Annie Fisher used to roll out her dough.

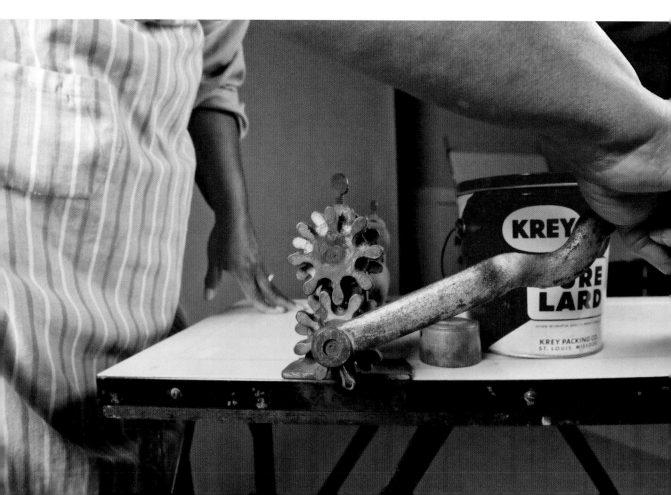

Meg Vatterott

named in her honor. But how to protect Fisher's legacy has also become a point of tension in town.

In 2011, Sheila Ruffin, a church and community leader in Columbia, campaigned for months to preserve the Wayside Inn. She wanted it to stand as a testament to Black achievement in town. But in the end, Ruffin was unable to raise enough money and community support to save it. The owners tore it down. More than a decade later, it's still overwhelming for her to go near that part of town.

"I felt like I failed," says Ruffin. "I can't get over that."

A historical marker on the African American Heritage Trail sits near the location of Fisher's first mansion, but that one's no longer standing, either. It was demolished in 1961 during urban renewal, a period when the federal government paid cities across the country to tear down neighborhoods they argued were "blighted." Hundreds of thousands of people were forced out of their homes, mostly people of color. In Fisher's former neighborhood alone, an estimated 303 families of color were displaced in the 1960s.

The only real place to remember Fisher now is Memorial Park Cemetery. When Sheila Ruffin first came to Fisher's grave, the headstone was covered in moss and standing water. But she complained to the cemetery, and they cleaned it up. Now, people come here sometimes and pay their respects.

IT'S TEMPTING TO WONDER: WHAT IF Columbia had honored Annie Fisher all along? That's a question food columnist Donna Battle Pierce has thought deeply about. Pierce moved to Columbia as a child in the 1950s. Her parents were educators, and she and her siblings were among the first Black students to integrate Columbia's public schools.

Pierce remembers how her teacher stood up and told her class, "If you don't want to play with Donna, you don't have to."

Back then, Pierce says knowing the story of Annie Fisher would have been deeply empowering—but she never learned about Fisher in school. Instead, she soaked up Black culture in the pages of *Ebony* magazine.

In college, Pierce was introduced to African American history and Black studies by poet Mari Evans—and she wondered why so little Black history and culture had been part of her grade-school curriculum.

Sometime in the 1990s, Pierce was back in Columbia visiting her parents when she saw Verna Laboy portraying the beaten biscuit trailblazer on television.

"I said, 'What the heck is this? How was it possible that this woman was in my community?'" recalls Pierce. It turned out that she and Fisher had a lot in common, from their love of cooking to their membership at St. Paul A.M.E Church. Pierce even realized that, as a teen, she had coveted Fisher's Wayside Inn. By that time, it was no longer a restaurant. It was just a beautiful house across from the Sky-Hi Drive-In, where she'd go with friends.

"I had no idea that a Black woman had lived there and had built that house," says Pierce. "I just could not believe that I had missed this part of Columbia's history."

In 1997, before the home was torn down, Pierce had the opportunity to tour it. She stood in the small kitchen where Fisher made thousands of beaten biscuits. In the future, she hopes Columbia will honor Annie Fisher with a museum—but until then, the best way she knows to keep Fisher's memory alive is by making her biscuits.

"There's just nothing any better in the world than a thin slice of country ham on a beaten biscuit," Pierce says.

By Pierce's estimation, there are hundreds more exceptional stories to be told just like Annie Fisher's in cities and towns across America. And Pierce says she's grateful that, thanks to people like Verna Laboy, more kids in Columbia now see themselves reflected in their city's history.

"This is what gives me energy to keep sharing Annie Fisher's story, as long as I have breath, because it's deserving," Verna Laboy says. "Her story is an American story. Her story is one of resilience and fortitude and rising above the perception of others." 🏆

Mackenzie Martin is a senior podcast producer and reporter at KCUR Studios in Kansas City, Missouri. She first reported on Annie Fisher for SFA's Gravy *podcast and the KCUR Studios podcast* A People's History of Kansas City.

THE POSTGAME MEAL

In Nashville, two elite soccer players bonded at the table.

by **MIKEIE HONDA REILAND**

Illustrations by **MOLLY BROOKS**

HANY MUKHTAR STANDS IN FRONT OF AN OCEAN OF GOLD, AN ENORMOUS black cowboy hat on his head, the captain's armband around his bicep. All around Geodis Park, the stadium on the hill that locals call "The Castle," fans in gold jerseys with his name on the back sing for him. "M-V-P! M-V-P!" It's spring in Music City, and Hany has just scored the third hat trick of his Nashville Soccer Club (NSC) career. He doffs the hat, bows his head, and grins—a giddy, defenseless smile that's rare for him, one that betrays a hint of sheepishness. *All this for me?* He returns the crowd's applause. He's waited years for this feeling. He left his home in Berlin and traveled to Lisbon, Salzburg, Copenhagen, and now Nashville, all in search of a club and crowd that believe in him like this.

Hany loves his life, so much so that in March 2023, on his twenty-eighth birthday, he married his partner, Ashley Gowder, on this same field. They met here in Nashville, and at their townhouse near The Gulch, they drink tea, talk trash over Mario Kart, and play with their dogs. He is excellent at his job, the reigning most valuable player of Major League Soccer (MLS). At Geodis Park, when he gets on the ball, an entire city seems to hold its breath, waiting to see what he'll do next.

There's just one thing missing. A few days after his hat trick, Hany grabs his phone and places a call to Charleston, South Carolina. He's trying to reach one of his closest friends: a former teammate he calls his little brother, another Muslim man with African roots making his way in the South.

"I miss you so much, man," Hany says into the phone.

"Yeah, me too, bro," the voice replies. "I miss you so much."

At seventeen years old, Hany Mukhtar became the second-youngest debutant ever to play for Hertha Berlin, his hometown club. At nineteen, he scored the winning goal for Germany in the finals of the Under-19 Euros. In the aftermath, he earned a transfer to Benfica, Portugal's largest club and a regular qualifier for the Champions League.

In Lisbon, Hany sat on the bench. Texts from friends grew scarce, then nonexistent. He left Lisbon for a year on loan in Salzburg, then returned to Benfica, only to find they didn't want him anymore. His agent said he could take a step down to the Danish Superliga, to a club based in the working-class suburbs of Copenhagen. In Denmark, the manager trusted him, the fans grew to love him, and in 2018, Hany won the league's player of the year award. He loved the order and discipline the fans displayed when they filed through the streets on the way to the stadium, so much so that whenever he scored, he ran to

them and saluted. That celebration became his signature.

Then the manager was sacked, Hany's importance waned, and in 2020, he moved to Nashville in search of the belief he craved. It didn't come right away. Throughout his first year in Nashville, Hany struggled with injuries and expectations. He scored only four times.

In October 2020, NSC traded with the Seattle Sounders for Handwalla Bwana. Handwalla was twenty-one, four years younger than Hany. A beard couldn't quite hide his baby face. He smiled a lot, and he seemed to approach most things, even his job as a professional athlete, with a hard-won ease. It was as if he knew that life could be much worse, so there was nothing left to fear.

Hany didn't spend much time with his new teammate at first—it was the first year of the Covid pandemic, after all. Then, in spring 2021, the Islamic holy month of Ramadan coincided with the beginning of the MLS season. Both practicing Muslims, Hany and Handwalla observed the customary fast of food and drink from sunup to sundown. Some days, temperatures pushed eighty degrees, and Hany and Handwalla abstained from even water as they pushed through ninety-minute matches and multi-hour training sessions. The two grew closer by sharing Iftar, the traditional fast-breaking meal, at Hany's home.

Though the two share a religious faith, they grew up on different continents in far different circumstances, with distinct relationships to food. For Handwalla, food had always been largely functional. He spent the first eleven years of his life in Kakuma, a refugee camp in the northwest corner of Kenya. His father was Somali, and the family's Muslim faith is part of why Kakuma felt like the safest place in Kenya, a mostly Christian nation. Handwalla spent most of his childhood waiting. To pass the time, he played soccer in the lanes outside his family's hut, where he dribbled balls he built out of trash, plastic bags, or inflated condoms. He mostly remembers these years as monotonous and relatively stable, so long as the sun was up. Many nights he heard gunshots, and one day, while he prayed in a mosque, a bullet grazed one of his relatives sitting ten feet away.

Food morphed from necessity to joy on the Fridays when Handwalla's mother, Fatima, would make pilau or biryani from the family's UN rations. That meal, Handwalla says, would hit *different*. Even when his family immigrated to Seattle by way of Atlanta, that rice remained special.

For Hany, though, food was a lifelong passion. His family's flat in south Berlin was filled with the smell of bread from local bakeries, along with homemade dumplings cooked by Ursula, Hany's Polish-German mother. Family meals were non-negotiable and could last for hours. Tea was always on, and you were expected to linger at the table. If Ursula didn't cook, they'd walk around the corner for sujuk, a Turkish breakfast sausage.

Hany cooks to demonstrate affection, as his now-wife, Ashley, learned the first time he cooked for her. She remembers watching as he julienned carrots, sliced chicken, washed sprouts, and rolled the ingredients into perfect spring rolls.

During Ramadan, Hany prepared similarly intricate Iftar feasts of soup, salads, chicken, and pasta for Handwalla. Handwalla's favorite was Hany's signature salad: lettuce, tomato, onion, green onion, pickles, avocado, cheese, and chicken, tossed in peanut-coconut dressing. Sometimes, after dinner, they'd retire to the living room couch to play FIFA on Hany's Xbox, still two kids in their twenties. Other nights, they'd sit at the kitchen table for hours, talking about soccer, their faith, and who they hoped to become.

After Ramadan, Hany and Handwalla built an easy routine. In the summer, they began to eat dinner together two or three times each week. They mostly ate at the townhouse, but sometimes they'd drive to Edessa, a Turkish spot in the Nolensville Pike strip mall that locals call Little Kurdistan.

Handwalla remembers evenings at Hany's, stretched out on the couch, stuffed with chicken and pasta, when Hany walked over and prodded him with a pack of Skittles or a tray of cookies.

"I got these amazing cookies," Hany might say. "You gotta try them." Handwalla would refuse, but Hany kept poking him. Finally, Handwalla would relent. Hany, far from appeased, would pressure him into eating more until the end of the night.

"Bro. I've got to drive home."

"No problem. You can sleep here!"

Too full of meat, veggies, and sweets to argue, Handwalla would drag himself upstairs and passed out in Hany's spare bedroom.

Hany loves food, so he probably indulges more than the average professional athlete. He cooks at home with groceries from Publix and

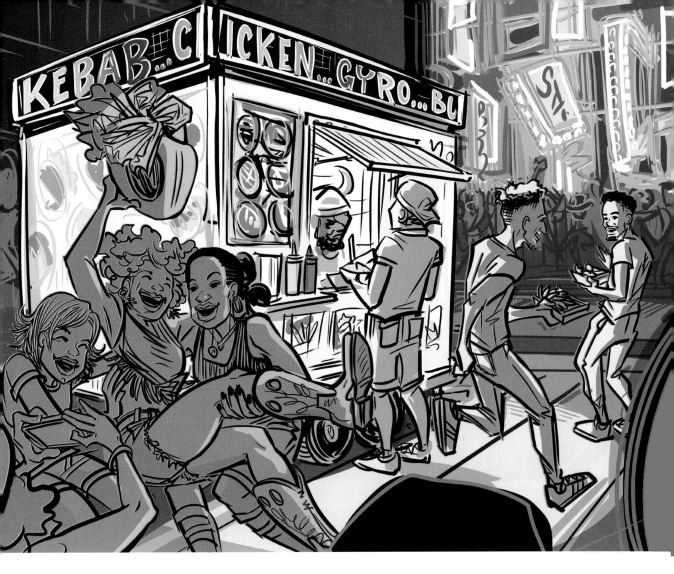

eats out with Ashley, favoring sushi at O-Ku, steak at Kayne Prime, and takeaway poke bowls. NSC prefers that its players stay below 10 percent body fat. At team weigh-ins, Handwalla delighted in pointing to Hany's stomach.

"You're gonna fail this," Handwalla said.

"No, no, no. This is muscle!"

Hany and Handwalla became so close that their teammates started calling them "Hany-and-Handy." When Hany messed up in training, Handwalla loved to point out his mistakes, as little brothers do. "Did you forget to eat breakfast today, Hany?" he'd say when Hany sailed a free kick over the bar. "You're so bad, bro."

Hany would laugh it off, and sometimes, he'd return fire. "You're so handsome," he once told Handwalla. "But man, your teeth are ugly."

After a home win on a Saturday night, Hany and Handwalla sometimes treated themselves to a meal from one of their staples: a gyro and kebab cart on Lower Broadway. On one of the South's most infamous party streets, two elite athletes—both teetotalers—waded into a sea of Miller High Life and bachelorettes in search of a stand that unabashedly traffics in drunk food. The chicken kebabs and the fries, Handwalla swears, are some of the best in the city.

In 2021, free from injury, Hany began to find his rhythm. In 2022, he won MVP of the entire league. He remained a force in the 2023 season, when NSC made it to the finals of the Leagues Cup before losing to Lionel Messi and Inter Miami. At an NSC game earlier this year, in the fifty-ninth minute, Hany received the ball near the endline, at such an acute angle to the goal that a shot seemed impossible. But Hany shot anyway, kicked it with such insolence and venom that the ball whizzed past the keeper's head and bulged the roof of the net before he could lift his arms. Behind the goal, a little girl looked at her dad,

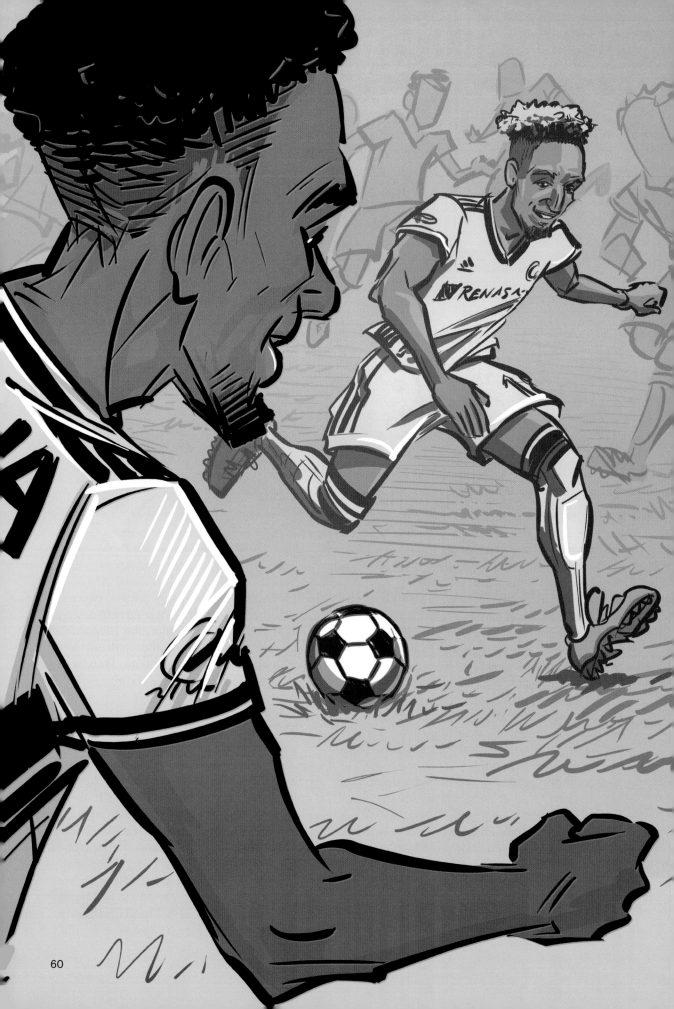

her mouth shaped like a perfect 0, and yanked her hand to her forehead. A salute, just like Hany. He's ascended to icon status here in Nashville.

Meanwhile, Handwalla struggled to conform his game to the team's style of play. No one on the team, not even Hany, was as good as him in one-on-one situations. He spent so much time with a garbage ball in Kakuma that it felt like his companion. Dribbling became an extension of the joy in his personality, and no one in the squad dribbled better than him. But NSC is a defensive team that relies on Hany to make the most of counterattacks.

In September 2022, NSC played a friendly at Geodis Park against Club América, the most famous team in Mexico. Since it wasn't a league or cup match, the manager gave Hany the night off. Handwalla entered the game at halftime, but less than half an hour later, he crumpled to the turf. He limped off the field, down the tunnel, and into the training room, where doctors evaluated him. They told him he'd strained his adductor.

Handwalla returned to his locker, where he sat by himself. The match went to penalties, and The Castle shook around him, noise stacking on top of itself. Left alone with his thoughts, he started to spiral. He didn't know yet, but could sense, that he'd played his last game in Nashville. *This place has been terrible for me*, he realized. He should've stayed in Seattle. His mother still lived there, and it was the closest place he'd ever had to a home.

When the game ended, the rest of the team trickled into the locker room. A few people checked on Handwalla, asking if he was okay before retreating to their own lockers. Handwalla had mostly kept it together, but he could feel panic start to yank at his composure. He needed crutches to walk, so he couldn't even drive home. It was Hany, who hadn't played, who sat down and put an arm around his friend.

"Come stay at my house," he said.

Ashley drove Handwalla's car to the townhouse, and Hany took Handwalla in his gold Range Rover. When they arrived, they ordered pizza, Hany's postgame meal of choice. They sat in the kitchen for hours, and Hany talked about the beginning of his career, how he'd struggled for playing time, how alone he'd felt away from his family when he lived in Lisbon and Salzburg, and how it had finally gone right here in Nashville. He could honestly say he knew what Handwalla felt. They talked about life, God, and why bad things happened. Then Handwalla wanted to go to sleep, so Hany cleaned the guest bedroom and helped him climb the stairs.

Around New Year's 2023, Handwalla and NSC decided to move forward without each other, and he signed for Charleston Battery, a club in the tier below MLS. After he and Hany shared one last meal at Edessa, Handwalla packed up his things and moved to Charleston. The club offered him the choice of two jersey numbers: 7 or 10. In Nashville, he'd worn 7, a traditional number for a dribbler like him. But for some reason, 7 no longer held any special appeal.

"Let me get 10," he told the team. Ten is Hany's number.

In the late summer of 2023, sitting on his couch in Mount Pleasant, South Carolina, Handwalla says he feels content. He's recovering from a torn ligament in his knee, but he's hopeful that he'll be back in MLS by next spring. He plans to visit Hany in Nashville this fall. Right now, aside from rehab and physical therapy, he takes sunset walks, goes to the beach, and eats a lot of Chick-fil-A.

At twenty-four years old, Handwalla sees his stint with NSC as two wasted years in a profession in which time is precious—elite male soccer players are likely to peak before the age of thirty. Yet he doesn't regret his time in Nashville. "I made friends who I can call twenty years later, you know? And Hany is someone who will always be a brother to me," Handwalla says.

Home and belonging are fleeting for professional footballers, who move from country to country and across continents and oceans to cling to a dream they had when they were kids. They breathe ambition like oxygen, but the pursuit of that dream is often lonely—a beautiful city where you don't speak the language, IKEA furniture in a sterile apartment, twenty minutes alone at your locker wondering if your career is over. Small joys and rituals, like a shared meal, can make you feel a little less rootless, like you actually belong somewhere. 🍸

Mikeie Honda Reiland is a writer from Nashville, where he also plays and coaches ultimate frisbee. His work has appeared in the Oxford American, Bitter Southerner, Nashville Scene, *and* SB Nation.

Photos by Jeremy Fleming

FROM BROWNSVILLE
TO GREENVILLE

At Comal 864, chef Dayna Lee brings a taste of the
Rio Grande Valley to upstate South Carolina.

BY CLINTON COLMENARES

DAYNA LEE LAYS A POUND OF SLICED BACON on the sizzling flat top. Next to the bacon, she squirts a little oil from a squeeze bottle and sets a couple of corn tortillas on top. The Saturday breakfast rush is about to begin.

Lee and her husband, Anthony Marquez, own and operate Comal 864 on Woodside Avenue in Greenville, South Carolina. (864 is a nod to upstate South Carolina's area code.) The neighborhood, City View, has yet to gentrify in the way that much of Greenville has over the last two decades. You won't find a micropub or a boutique hotel around here. Within two blocks of the restaurant are a couple of tire shops, a shade tree mechanic, and an aged mobile home park.

Lee didn't go to culinary school. She never staged or cooked on a line. Before opening Comal 864, her restaurant experience came from years of managing a Texas Roadhouse in her hometown of Brownsville, Texas. But for years she's nurtured a drive to cook for people in her adopted hometown, motivated as much by a call to service as by culinary passion.

In 2016, Lee and Marquez left Brownsville for Greenville, where Marquez had taken a job as an engineer. At the time, Lee was twenty-four, and her son, Abel, was two. It was her first time outside the Rio Grande Valley, where more than 90 percent of residents are Latino. (Lee's father was not Latino, but she grew up primarily with her Mexican American mother, stepfather, and grandmother.) Greenville, by contrast, is only 6 percent Latino. She didn't know anyone. A twenty-hour drive separated her from her family. She found the traffic dizzying and the Blue Ridge foothills disorienting in contrast to the flat landscape of south Texas. She didn't leave the family's new apartment for two weeks.

Though Lee learned to cook alongside her grandmother as a child, she didn't imagine a career in food. When she first began cooking in Greenville, she just wanted Abel to grow up with the smells and flavors of her home—from the homemade tortillas with stewed meat her grandmother packed for her stepfather's lunch to the pork and raisin tamales the family made together for the holidays.

"The scarcity of our food was what propelled me," Lee recalls. "I was desperate for a recreation of what I had been eating back home. I wanted to feel that again."

She tried, and failed, to find familiar dishes in Greenville's restaurants. The food at Mexican

LEFT TO RIGHT: Dayna Lee in front of Comal 864, the restaurant she owns and operates in Greenville, SC; Comal 864's chilquiles rojos

"To be able to be a good mom and be a good wife and still do this kick-ass shit, that's tenacity."

With no recorded family recipes, she cooked from memory. Some dishes turned out awful at first. She tried them again.

restaurants that catered to white patrons tasted bland to her. Other Latino-owned restaurants that served a primarily Latino clientele tended to specialize in Honduran, Salvadoran, or Guatemalan cuisine.

With no recorded family recipes, she cooked from memory. Some dishes turned out awful. She tried them again.

Meanwhile, she took a job that included arranging catering for events. She began handing out leftovers to unhoused people in downtown Greenville. Giving food away became her way of contributing to the community and began helping her find her place in it.

At home, Lee's cooking improved, becoming recognizable to Anthony and Abel. The flavors and textures were reminiscent of her abuelita's guisados. In July 2019, she had the notion to make breakfast tacos—eggs and potatoes, eggs and chorizo—and sell them at local breweries

on the weekends. At first, she admits, "they were terrible." But she was determined to improve, and to find out if she could make a business out of selling tacos. The food got better, and within a few months, she was selling $500 worth of tacos in a few hours, four to five days a week.

A regular at one of the breweries, a commercial realtor, called Lee one day. He knew of a small building that would be perfect for her if she wanted to open a restaurant. The place had been a bistro that moved into plusher digs in a converted textile mill down the street. Lee was enjoying the low overhead and fairly easy cash of selling tacos. She wasn't looking to open a restaurant, but she was also pulled by the opportunity to do more—more cooking and more for her neighbors.

Lee and Marquez signed the lease in September 2021. After months spent scrubbing and prepping the space, they opened Comal 864 that November.

BELOW: Dayna Lee preps in the kitchen at Comal 864; OPPOSITE, TOP to BOTTOM:
Cucumber slices topped with Tajín and lime; Birria burrito with salsa verde

Some of the items on Lee's menu are by now familiar to many, if not most, diners in the US South: quesadillas, tortas, and tacos filled with bistek, chorizo, nopales, chicken, or al pastor pork. Others have a more specific sense of place, revealing Lee's roots on the Texas-Mexico border. There, she explains, the palate leans tangy, sweet, and sour, punctuated with spicy heat. Pickled pork rinds with watermelon, oranges, or other fruit are a frequent treat. So are hot dogs topped with salsa. At Comal 864, customers can elect to add Hot Cheetos or queso to any torta or burrito, a practice she says is common around Brownsville.

Lee wants her customers to eat well. Even so, she says, "I love food for what it *does*. I don't love food because it's food." In those early Greenville days, food was a conduit back to Brownsville. With the opening of Comal 864, it became a jumping-off point for community efforts.

Last December, Lee held a coat drive at the restaurant. She regularly leaves items like school supplies and baby wipes on the picnic tables in front of the restaurant, where neighbors can pick up what they need. She sat in a dunking booth during a local pub's Pride festivities. Every day, Lee says, someone walks in and asks for a free meal. She responds by handing over a heaping plate, no questions asked. She's trained her staff to do the same. By her count, as of June 2023, Comal 864 had given away at least 3,700 tacos.

This past spring, Lee was invited to cook at Charleston Wine + Food, a popular festival. She met Luis Martinez, an Asheville, North Carolina–based chef consultant and the owner of Tequio Foods, which works with indigenous farmers in Mexico to import heritage ingredients to the United States. "In the last couple of years, the word 'chef' has been misused," Martinez says. "For me, a chef is a leader, someone who is making a change in a community. I feel like what she's doing is a chef's role."

Lee believes Greenville might have accepted her, in part, because of her fair skin. Still, says Evelyn Lugo of the South Carolina Hispanic Chamber of Commerce, the success of Comal 864 will inspire other Latina-owned businesses. "In every single Latin American country, women are more on the second, maybe third level," says Lugo. "The man is always here [at the top], the women are always at home, cooking, taking care of the kids."

But Lee?

"Here she is, being the face of her own business," Lugo says. "*Trabajando duro*. Really, really, really hard work."

Lee embraces the challenge. "I'm a good example of tenacity, of being scared but doing it anyways." Growing up, it was expected that she would one day be a wife and mother—not a business owner or community leader. "So to be able to be a good mom and be a good wife and still do this kick-ass shit, that's tenacity."

Back at Comal's flat top on Saturday morning, Lee spoons eggs onto the sizzling surface then places chorizo on top, so the meat doesn't burn. It's a cooking trick she learned, like all the others, by trial and error. She slices a hot dog lengthwise and places it on the grill. After a few minutes, she folds the egg, chorizo, and hot dog into a warm tortilla and hands it across the counter to Marquez. The two of them grew up on this dish, weenie con huevos. It's a south Texas staple, now at home in Greenville, South Carolina. 🍸

Clinton Colmenares grew up in Texas with family roots in Oaxaca, Mexico. He lives in Greenville, South Carolina, and works in communications at Furman University.

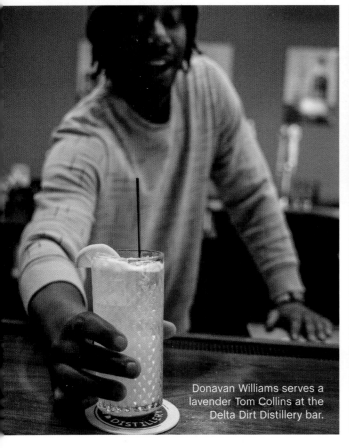

Donavan Williams serves a lavender Tom Collins at the Delta Dirt Distillery bar.

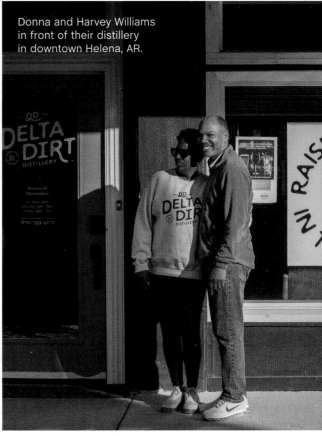

Donna and Harvey Williams in front of their distillery in downtown Helena, AR.

Sweet as Pie

EVER SINCE AMERICAN SWEET POTATOES REPLACED AFRICAN YAMS AS a dietary staple of enslaved Black folks in the South, they have been an essential part of the canon. For centuries, Black Americans have highlighted the beauty and versatility of this root vegetable: baked over coals, smoothed into casseroles, sliced and candied in buttery syrup, and whipped to fill pies. Today, in Helena, Arkansas, you can even drink them. Delta Dirt Distillery transforms sweet potatoes into its signature vodka. Harvey and Donna Williams own and operate the place with their sons Thomas and Donavan and use produce from Harvey Williams' ancestral farm just outside Helena. Visitors to their brick headquarters downtown on Cherry Street can watch the distilling process and sample Delta Dirt cocktails. Making alcohol from sweet potatoes is not new. Yet the idea that a Black family in the Delta might use this commodity crop and this process to bring vitality and entrepreneurship to a quiet, old Mississippi River port town is notable. So, too, says Harvey Williams, is their Rose on the Delta cocktail, made from the distillation of their farm's signature crop: "When people hear there's a sweet potato vodka, I think there's more intrigue there."

Photos by ANDREA MORALES
Text by KAYLA STEWART